Weegee
by Kerry William Purcell

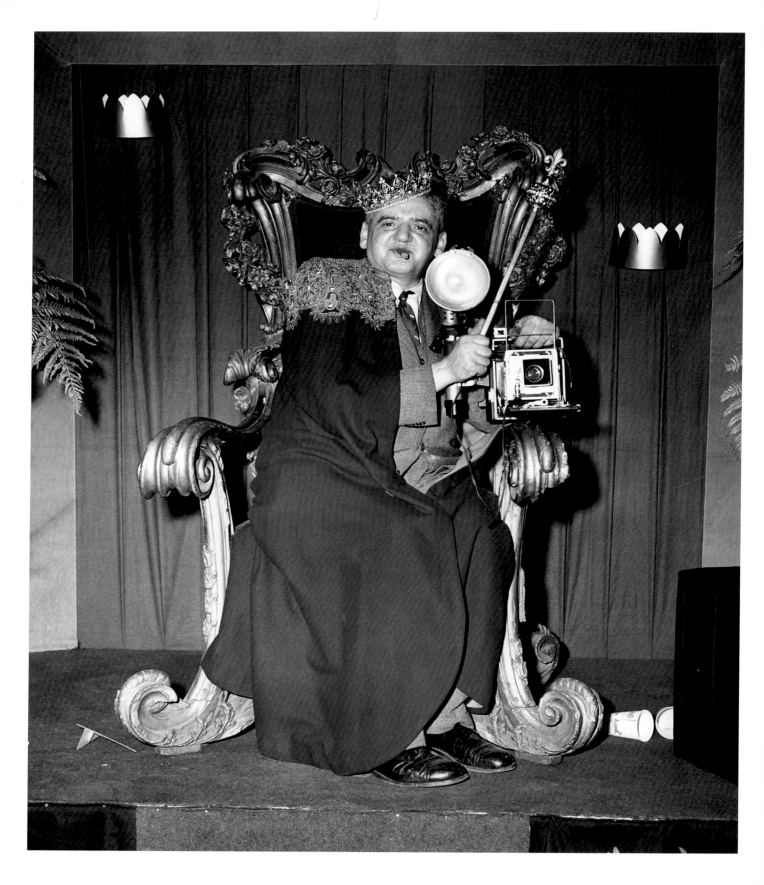

'To me a photograph is a page from life, and that being the case, it must be real.' Weegee

Weegee was the archetypal news photographer of the twentieth century. From the mid 1930s to the 1940s his photographs offered tales from the grimy underbelly of the urban everyday to readers of the New York tabloids. Nicknamed Weegee, after the Ouija board, because of his inexplicable ability to arrive at a crime scene before the police, his forte was the unexpected spectacles of murder, fires and automobile accidents. A compelling witness, Weegee's camera apprehended households escaping conflagrations, gangland victims surrounded by fascinated spectators, and the twisted torsos of car crashes. Alongside the random misfortunes of existence in a modern metropolis, he also focused his camera on the pleasurable moments of city life: secret lovers at the cinema, drunken revellers in a bar, singers and dancers in a swinging nightclub. Weegee condensed whole lives into a single picture, from the grievous to the joyous, cropped and framed in readiness for the next day's newspaper. Through his viewfinder, New York City became a permanent performance: the tenement doorway, the shop front or the car window served as his improvised proscenium arch. Weegee's photographs delineated the raw truth of the characters' lives, illuminated in the burst of his flash. Transcending the evanescent publications they were featured in, his images still have the power to startle, shock and move in a profound way.

Weegee was born Usher Fellig on 12 June 1899, in Zlothev, a small village near the city of Lemberg (Lvov) in the former Austrian province of Galicia (now part of Ukraine). His Jewish

Weegee, photographer unknown, c. 1956

parents, Bernard and Rachel Fellig, ran a small grocery and supplies business in Lemberg. According to Miles Barth, in his monograph *Weegee's World* (1997), it was due to the intensifying climate of anti-Semitism throughout central Europe that the Felligs eventually lost their family business. Like many before and after, Bernard Fellig saw the chance to emigrate to America as the path to a new life. In 1906 he left for the United States. After saving enough money, he sent for his wife and family in 1910.

When the ten-year-old Usher Fellig entered the immigration port of Ellis Island, New York, the officer who examined the Felligs' identification papers Americanized his name, changing it from Usher to Arthur. With his mother, two brothers and one sister, Arthur Fellig followed his father to his two-room apartment in the overcrowded district of the Lower East Side, Manhattan. After a short time, the Felligs left this small flat and moved into a cold-water tenement where Arthur's parents were employed as cleaners. In his autobiography, *Weegee by Weegee* (1961), he described this flat as having 'three rooms on the fifth floor ... [with] one hall toilet for four families'.

As for most new immigrants, life was tough for the young Arthur Fellig. Part of the problem seemed to be that his pious father refused to work on the Sabbath. When Bernard Fellig did find work, as a pushcart peddler selling crockery to Jewish housewives, he found it hard and financially unrewarding. With the need to bring more money into the household, it was not long before young Arthur took to the street in search of work. One of his first jobs was selling newspapers after school. When this failed to increase the family income, he tried selling sweets to the workers in the sweat factories. In 1913 Arthur Fellig made the decision to quit school so he could enter the world of employment on a more permanent basis. It was around this time, after having his picture taken on a pony by a street tintype photographer, that Fellig began to develop an early

interest in photography. Acquiring his own tintype kit and pony, he began to photograph kids in the street and sell the one-off prints to the children's parents. Not making enough to cover the expense of keeping a pony in stables, Fellig's first job in photography soon came to an abrupt end.

In 1917 Fellig decided to escape the oppressive religious atmosphere of the family home (his father was soon to realize his ambition of becoming a rabbi at the local synagogue). After sleeping rough in missions, parks and railway stations, the brief experience Fellig gained as a tintype photographer enabled him to achieve the position of assistant at the Ducket and Adler photography studios in Lower Manhattan. He assisted the photographer through a variety of errands and darkroom tasks, creating photographs of products for travelling salesmen. Two years later, when the chief camera-operator had left, Fellig began to take on more significant duties. With these extra responsibilities, he assumed he would be receiving extra pay. When the owner of the studios refused to increase his wage packet, however, he quit.

Throughout the 1920s and 1930s, tabloid newspapers, such as the *Daily News,* the *New York World-Telegram* and the *New York Post*, published images of accidents and murders that were still being washed off the sidewalk when the paper hit the streets. As a large proportion of the tabloid readership was semi-literate immigrants, these pictures offered an easy way to keep abreast of breaking news and identify the key players of a story in one quick glance. Fellig had his first opportunity to witness this news process from the inside when, in 1921, he successfully obtained a part-time position as a helper in the darkrooms of the *New York Times*. With the picture syndication agency Wide World Photos also operating as a subsidiary of the *New York Times*, he became acutely aware of how news was filtered and which photograph was guaranteed to catch the editor's eye and make the front page of the next day's newspaper.

Around 1924 Fellig applied for, and successfully obtained, the job of darkroom technician and printer for Acme Newspictures (later incorporated into United Press International). Earning fifty dollars a week, he developed and printed photographs for publications such as the *Daily News* and the *New York Herald Tribune.* Happy for perhaps the first time in his life, Fellig noted in his memoir that 'the smell of the developing and hypo chemicals was intoxicating. Also, I was learning photography in that darkroom. Later, when I went out to cover stories myself, I could visualize how my pictures would look in the enlarger.'

After a few years, Fellig felt his talents were being wasted as a darkroom man. He requested promotion to the post of photographer but refused to accede to the Acme rule that, when covering a story, all staff must wear a white shirt and tie. Nevertheless, as the tieless Fellig worked the nightshift, he began to cover the emergency stories that the regular staff photographers, asleep at home, could not. At first he was limited to photographing fires. But in the decade he spent at Acme (c. 1924–35), his repertoire slowly expanded to include traffic accidents, murders and police arrests. Whether on his own or partnering an Acme journalist, Fellig, with his first camera (a 4 x 6 inch ICA German Trix), began to develop the repository of skills essential to any news photographer at the time. To achieve maximum exposure and sharpness of image, he would set the aperture of his lens at f.16, the speed of exposure at 1/200 of a second, and would stand about ten feet from his subject matter. Combined with the use of the flash bulb introduced by General Electric in 1930 (Fellig was one of the first photographers to use the new tool), this technical and aesthetic approach to the dramatic, often shockingly graphic, images in tabloid photography would be employed by Fellig throughout his long career.

In the expeditious world of picture syndication, Fellig prided himself on his ability to beat all the other news agencies to that

exclusive photograph. To be the first to wire an image to papers around the United States, he would use any means possible to make it to the telephone company office ahead of the competition. One famous example, recounted in his autobiography, was when he was asked to cover a world-championship boxing match: 'I arrived in a rented private ambulance, and we'd park ready for a quick getaway. I would be hidden inside. After the first knockout, a messenger would rush the exposed holder to me. Then, with sirens screaming, red lights flashing, and cops clearing the way, we'd make a mad rush downtown. While the ambulance sped, I lay on the floor, developing the glass negative. Another scoop for Acme.' Fellig's uncanny talent for pre-empting the news, for always acquiring the first pictures of an event, soon began to attract the attention of his colleagues. With the craze for Ouija boards at its height in the 1930s, many of the staff at Acme playfully alluded to Fellig's seemingly psychic powers by referring to him phonetically as 'Weegee'. An alternative explanation for the nickname came from some of the Acme editors. Apparently, staying up late into the night in the Acme darkroom, not washing or shaving, Fellig began to resemble one of the begrimed characters that illustrate the Ouija board (see Barth, *Weegee's World*). Whatever the source of the nickname, he would introduce himself as Weegee for the rest of his life.

On paydays at Acme, all the photographers would play a game of crap. One Friday, Weegee gambled and lost all his wages. Unable to pay his rent, he decided to leave his seedy one-room apartment and move into the Acme darkroom. Bringing his own mattress and bedding, he set up home on one of the shelves and lived off Heinz baked beans and Uneeda biscuits. One of the perks of Weegee's new accommodation was that he now had the opportunity to be first to the Acme ticker-tape machine and to scoop all the overnight stories. Early one morning, at around 4 a.m., the ticker-tape machine started to flash and ring, reporting a plane crash in Ohio. Clearly, it was

not possible for Weegee to cover the story himself. He would have to phone the editors who would arrange for photographs of the crash to be sent to New York. Yet if he did, Weegee knew that they would enquire what he was doing in the office in the early hours of the morning. Unable to resist the lure of securing another scoop for Acme, Weegee phoned his editors who made the necessary arrangements. The next day, Weegee was evicted from his new place of residence and instructed to find alternative accommodation.

In 1935 Weegee vacated the darkroom on a more permanent basis by going freelance. From the connections he had made through Acme, his new business address became the offices of the Manhattan Police Headquarters. For the next ten years this would be the first port of call on his nightly beat. 'I would arrive at midnight,' he recounted in *Weegee on Weegee*, 'the cop at the information desk would be dozing ... The police Teletype machine would be singing a song of crime and violence ... Crime was my oyster, and I liked it.' He rented a room for seventeen dollars a month behind police headquarters so that he could be first on the scene. Next to his bed he had installed a radio that was wired up to receive both the police signals from the radio despatcher and the fire bells from the fire station. Initially, Weegee rode with the police to a crime scene, but soon bought his own 1938 Chevy Coupe. In 1938 he became the first civilian to be granted permission to install and operate a shortwave radio capable of receiving police and fire transmissions in his car.

It was not long before Weegee started to make a name for himself. Papers such as the *Daily Mirror* and the *Daily News* began to depend on his coverage of any murder or major fire that took place before sunrise. Now using a 4 x 5 inch Speed Graphic camera with a Graflex-synchronized flash – the archetypal press camera until the early 1960s – Weegee was swift to stamp his signature on the world of photojournalism. From

1938 he began to mark the back of his photographs with the trademark 'Credit Photo By Weegee The Famous'.

In the early years of newspaper photography, the essential task of the photographer was to illustrate the text; to make literal the words of the journalist. During the 1930s this balance began to shift: the photographer began to dictate the parameters of a story and determine the writer's response to an event. Weegee was central to this change in working practice. Arriving at an incident, he would quickly cast his eye over the scene. Making any necessary adjustments, he would stand at the obligatory distance of ten feet and take the shot, condensing as much information into one frame as possible. An accompanying caption frequently became irrelevant. For example, on numerous occasions Weegee photographed an incident so that an adjacent street sign or advertisement would create a whimsical associa- tion with a murder victim or tenement fire. Occasionally, it was pure luck that the two coincided, as with the 'Simply Add Boiling Water' advertisement for frankfurters in the c. 1937 image of a fire (no. 02). On other occasions, such as the 1939 photograph 'Victim of Auto Accident' (no. 06), Weegee choreographed the scene himself, placing a steering wheel in the corpse's hand to create a wry comment on man's love affair with the automobile. Such 'set design', whether incidental or contrived, gives Weegee's best work an almost filmic quality, transforming New York's streets into a cinematic set.

Parallel to the crime and gangster films of the 1940s (collec- tively known as *film noir*), Weegee's photographs exposed the flip side of city life. Roaming the streets of Manhattan, he uncovered a twilight world, one ordinarily hidden from the daytime inhabitants of the city. Through the revelatory power of his flashgun, Weegee illuminated dramatic scenes inhabited by individuals who signified a city dweller's deepest fears (aching loneliness, random violence and destitution). For the majority of the tabloid audience, the naked truth of these

images must have seemed like missives from another place. Viewed in the clear light of day, they were more akin to half-remembered images from a nightmare than anything gleaned from direct experience. Yet, largely because of this surreal quality, the general public was by turns shocked, appalled and fascinated by the subjects that he depicted. Glanced at on the newsstand, Weegee's photographs had the power to captivate the tabloid reader, sparking a real desire to know more about the story.

From 1940, Weegee began working for the liberal New York newspaper *PM Daily*. From its inception, *PM* was unlike any other tabloid paper. Through its picture editor, William McCleery, *PM* was committed to promoting photography of the highest quality and Weegee's fellow photographers included such celebrated figures as Margaret Bourke-White and Lisette Model. The picture editor of the Sunday edition of *PM* was the photographer Ralph Steiner. Steiner said in his autobiography *A Point of View* (1978) that his aim with *PM* was to 'draw the attention of the general public to unusual photographers and what they were saying in their work'.

It indicates how far Weegee had progressed from his days at Acme that *PM* gave him carte blanche when selecting the events he wished to cover. Occasionally, *PM* also consented to him writing the stories that accompanied the pictures. As a contributing photographer (Weegee repeatedly declined offers of a permanent staff position), his only obligation to *PM* was to provide its editors with first viewing of his previous night's work. Even though he continued to document the many crime scenes and accidents in Manhattan, this new editorial freedom gave Weegee the chance to expand his repertoire. Liberated from the call of the police radio and Teletype machine, he began to chronicle the pleasures of city life. With his photographs of Sammy's bar on the Bowery (nos. 28, 30, 50), the Easter Sunday celebrations in Harlem (no. 08) and, most

famously, the crowds at Coney Island (no. 11), it was during his time at *PM* (1940–4) that Weegee produced some of his most iconic images.

In August 1941 Weegee enjoyed his first one-man exhibition. Held in New York at the Photo League (an organization that promoted photographers such as Berenice Abbott, Helen Levitt and Sid Grossman), it was entitled 'Weegee: Murder is My Business'. While not attracted to its leftist political agenda, Weegee used the Photo League to reframe public perceptions of his work. Unlike the editors of the New York dailies, who usually judged his work by the capricious values of 'news worthiness', a new audience was willing to accept his photos on their artistic merit alone. This reappraisal of Weegee's photographs was enhanced when his work featured in two group shows at the Museum of Modern Art, New York. Entitled 'Action Photography' (1943) and 'Art in Progress' (1944), these exhibitions signalled a growing institutional recognition of Weegee's images, acknowledging their lasting value beyond the fleeting and ephemeral events they depicted. In 1944, following these exhibitions, Weegee was invited to hold a workshop at MoMA. After this session, members of the audience suggested that he should produce a book.

In 1945, after many other publishers had turned it down on the grounds that it presented an unflattering picture of New York, Duell, Sloan and Pearce decided to publish Weegee's first book, *Naked City*. It was an instant success. Reprinted several times during the first year, it received enthusiastic reviews. Acting as a punctuation point, *Naked City* marked the conclusion of the most creative chapter of Weegee's career. It acknowledged that his photography was of more enduring significance than the short-lived publications it had been featured in. Identifying news photography as an aesthetic form worthy of attention in itself, it is a seminal book in the history of the medium. *Naked City* also signalled the beginning of Weegee's diminishing

interest in tabloid photography. He was 'tired of gangsters lying dead with their guts spewed in the gutter, of women crying at tenement house fires, of automobile accidents. In my ten years at police headquarters, there had been at least one murder every night. I must have covered nearly 5,000 of them … I was sick of murders' (*Weegee by Weegee*). With the release of *Naked City*, quickly followed by the publication of his second book entitled *Weegee's People* (1946), Weegee saw an escape route. The increasing number of assignments he began to receive from magazines such as *Vogue*, *Life* and *Seventeen* provided him with features that had nothing to do with lurid scenes of crime and horror. Photographing exhibitions of modern art, society events and fashion shoots, Weegee began to make what he termed 'lush money'.

During the mid 1940s, as an antidote to morbid crime work, Weegee began to develop a serious interest in filmmaking. In 1948 he made a short, twenty-minute film entitled *New York*. Over the years, he made a further seven films of varying quality and length. Given the almost filmic quality of *Naked City*, it was probably already clear to Weegee that his best-selling book could easily be translated into a full-length feature film. When in 1947 he was visited by the Hollywood film producer Mark Hellinger, who was interested in buying the title of the book, Weegee grasped the opportunity to escape news photography altogether. He sold the rights for *Naked City* to Universal International Pictures and was also employed as a special consultant on the dramatization of his monograph, which was partially filmed on location in New York and directed by Jules Dassin. Weegee's experience of working on the set of *Naked City* sparked dreams of making it big in the movie business and, after a nationwide book tour, he finally turned his back on the world of tabloid photography and left New York for Hollywood in 1947.

With the publication of *Naked City*, 'Weegee the personality'

began to eclipse 'Weegee the photographer'. Now perhaps the most celebrated news photographer in America, he promoted himself in Hollywood as the quintessential hard-boiled, cigar-smoking, flashgun-popping character we have come to know from numerous pulp fiction storylines. Frequently playing a parody of himself, Weegee was able to secure a handful of minor walk-on roles in several Hollywood pictures. In the films *Every Girl Should Be Married* (1948), *The Set Up* (1949) and *Journey into Light* (1951), he respectively portrayed a street photographer, boxing-match timekeeper and skid-row bum.

To supplement the meagre income from his uncertain acting career, Weegee also freelanced as a technical adviser to the film studios. On pictures such as *The Yellow Cab Man* (1950), he illustrated the new range of special-effects techniques he had begun to develop in the late 1940s. With the various trick camera lenses that he invented, Weegee also began to produce a series of distorted photographs of celebrities and film stars. These creations were eventually published in his third book, *Naked Hollywood* (1953). Weegee used an array of prisms, kaleido-scopes and various optical tricks to produce these distortions. The results included images of French President Charles de Gaulle with an elongated chin, Pablo Picasso in the style of a Cubist painting and Fidel Castro in an Edvard Munch-style scream. Trading on his newly found fame, Weegee also applied these techniques to a variety of products, including champagne and perfume bottles. Of all these works the best known is the contorted image of Marilyn Monroe (no.55). This distended caricature pokes fun at the inflated egos and pretensions of an entertainment industry that Weegee longed to be accepted by. Soured by his experience in Los Angeles (in his autobiography, Weegee referred to Hollywood as the 'Land of the Zombies'), he returned to New York in 1952.

Throughout the 1950s, Weegee continued to develop and promote his trick photography effects. However, with some

justification, few critics took this aspect of his work seriously. For them, he would always be Weegee the tabloid photographer, the documenter of murders, fires and accidents. Partly as a response to this attitude, Weegee spent much of the late 1950s and 1960s travelling throughout Europe. In 1959, always looking for opportunities to produce new work, he lectured and exhibited in the Soviet Union. The following year, he held an exhibition of his caricatures in Cologne, Germany. He also worked for various newspapers in the United Kingdom, such as the *Daily Mirror* and *The Times*. In addition, he revived his role as special-effects consultant for Stanley Kubrick's classic anti-war film *Dr Strangelove or: How I Learned to Stop Worrying and Love the Bomb* (1964). On 25 December 1968, Weegee died of a brain tumour in New York City. He was sixty-nine years old.

Now held at the International Center of Photography, New York, Weegee's lifetime work consists of over 13,000 prints and negatives. Yet, as captivating chronicles of the dramatic and shocking, it will always be his photographs of New York in the 1930s and 1940s that form the basis for the creative legacy of 'Weegee The Famous'. Catching people unawares, at their most vulnerable or exuberant, these images reduce the gap between viewer and subject to barely touching distance. Blurring the boundaries of public and private, they compel you to look or turn away – in either case, they charge you to make a judgement, to react. As time weakens their historical specificity, the originality of these photographs becomes even more apparent. Collected together, they form a lyrical ballad that transcends their original objective of reportage. They are a visual poem, dedicated to the city that inspired Weegee's unique vision.

7 August 1936 | Corpse with Revolver.

The high-contrast lighting produced by Weegee's synchronized flashgun was more than just a stylistic preference. The experience he acquired while working as a darkroom technician for Acme Newspictures taught him that the delicate tonal range of any image would be lost when reproduced on low-grade tabloid newspaper. By composing a picture consisting of deep heavy blacks and glaring vivid whites, Weegee knew his photographs were guaranteed to survive the printing process. In this photograph for the *New York Post*, the begrimed sidewalk sets off the white hat, while the fading darkness of the night increases the prominence of the corpse.

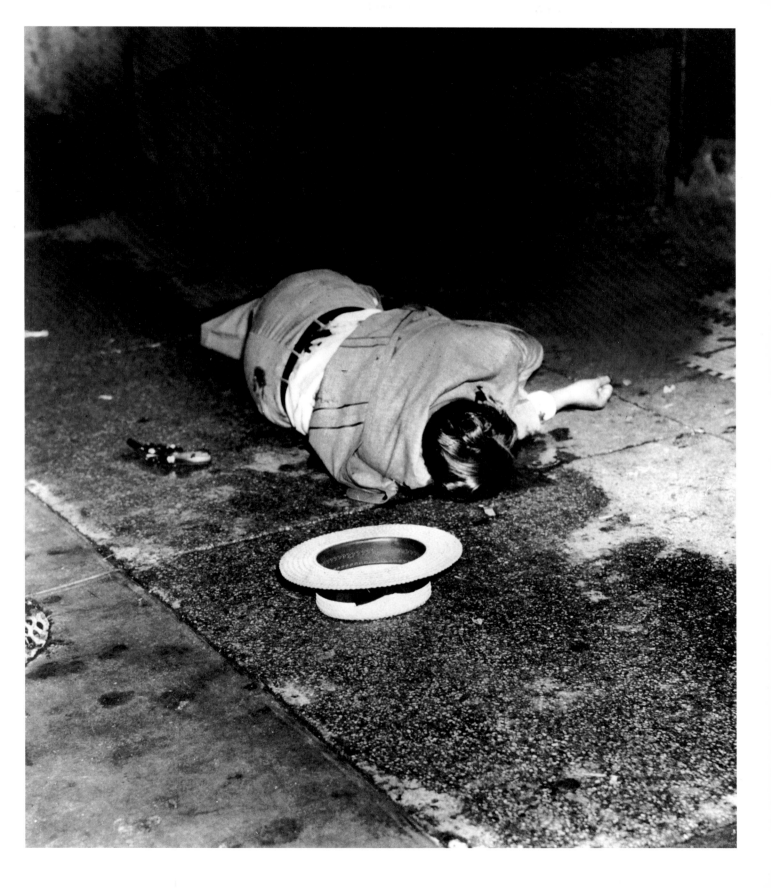

c. 1937 Simply Add Boiling Water.

Framing a scene so that a nearby sign or advertisement would create a sardonic juxtaposition with the event depicted was a common leitmotif in Weegee's work. However, on this occasion, the positioning of the phrase 'Simply add boiling water' was pure chance. Nevertheless, even with this fortuitous (for Weegee) concurrence, he still had to draw on all his technical ability to obtain this striking image. With the distance illuminated by his flashgun limited to around ten feet, Weegee would have resorted to the use of flash powder. Handling this notoriously volatile material, he was able to generate enough light to capture the raging inferno.

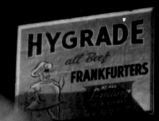

c. 1937 Summer on the Lower East Side.

Witnessed in the work of photographers such as Helen Levitt and Paul Himmel, children playing in the water from a fire hydrant has been a popular subject for many New York photographers. In this scene, the hydrant's high-pressure spray provides a welcome relief from the summer heat. The shrieks and screams of exuberant children are enjoyed from afar by their parents.

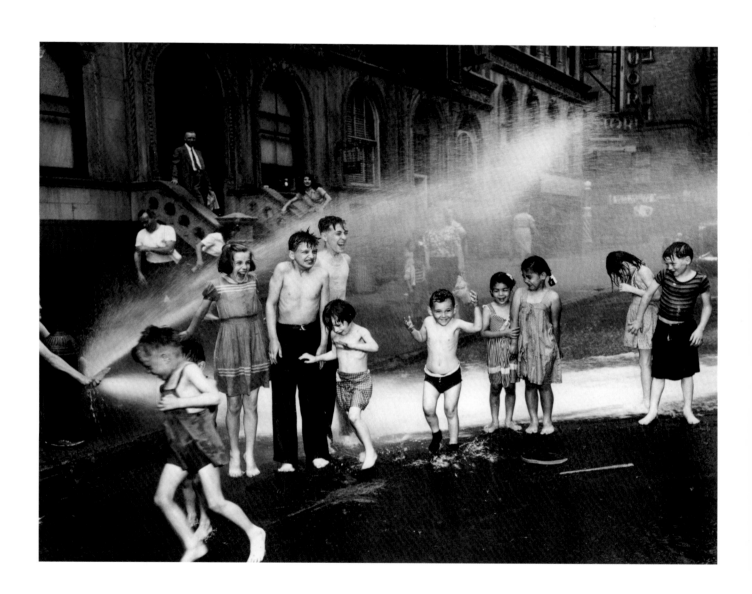

15 January 1937 | Wife of Major Green Being Escorted Out of Police Station.

The traumatic condition of Mrs Green, being taken home after hearing that her husband has just confessed to murder, is in stark contrast to the impassive appearance of the accompanying officer. The surprise arrest of her husband took place in the middle of the night. Appearing still to be wearing her nightdress, Mrs Green only had time to grab her hat and coat to protect her from the chill winter's night. Departing the police station, she physically recoils from the disturbing reality that has now been publicly acknowledged by the stark light of Weegee's flash.

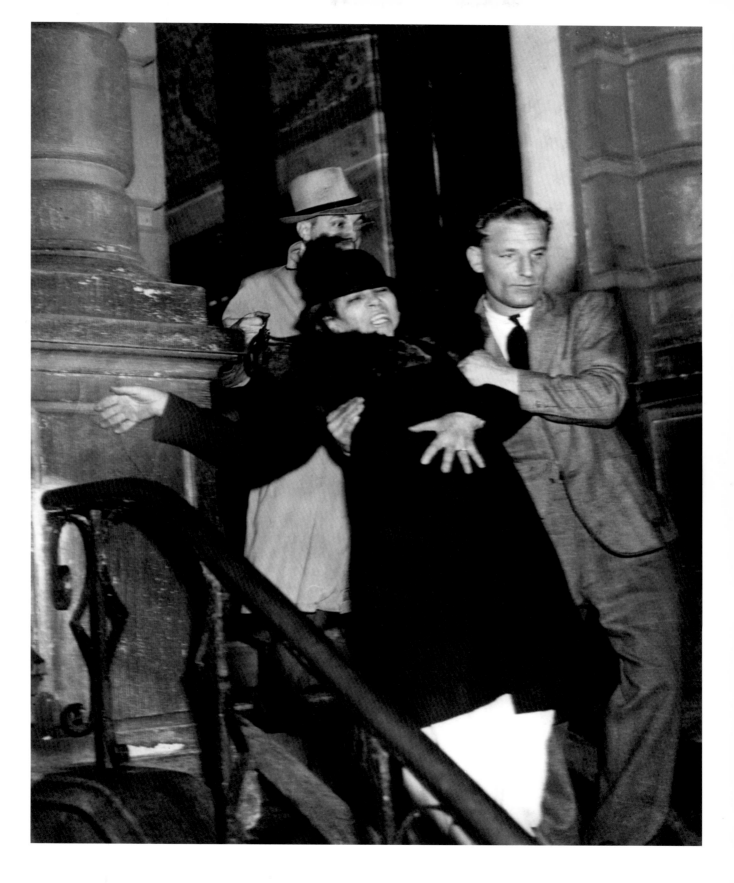

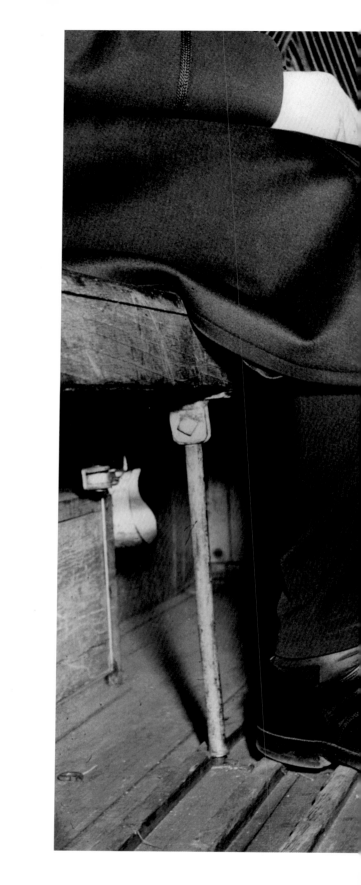

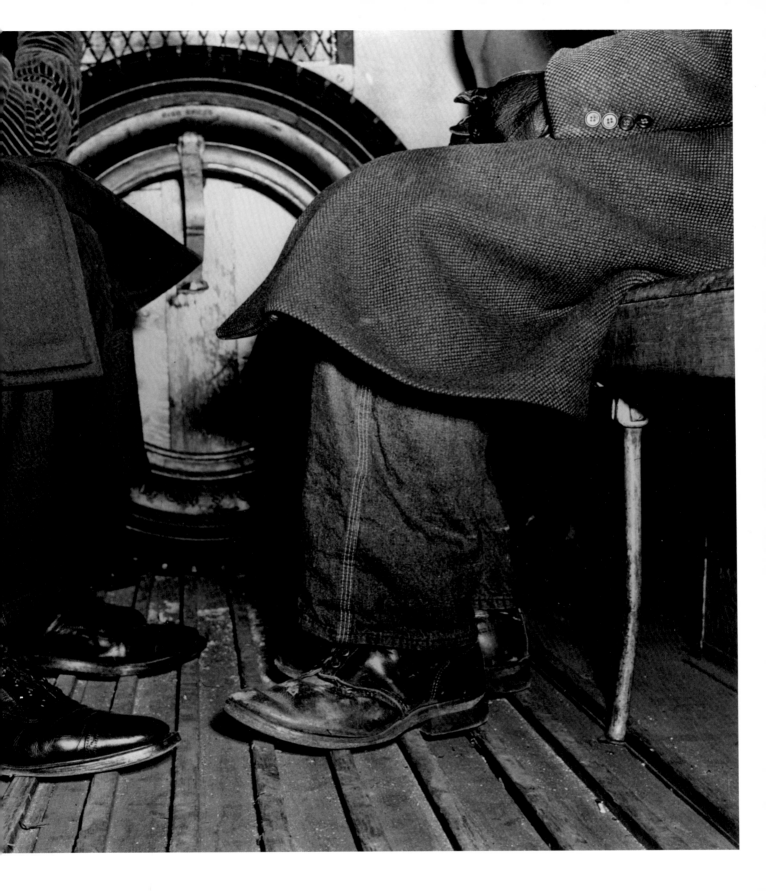

05 *previous page* 17 February 1937 'Factory Frankie' Aherns (left) and Marty Powell (right)
Arrested for Association.

As they refused to have their picture taken, Weegee took the novel approach of photographing these two offenders from the waist down. When making this decision Weegee knew that, even though we cannot see their faces, we can still glean a considerable amount of information from the men's attire. Looking at the quality of their shoes, trousers and coats, we quickly reach the conclusion that the man on the left probably has the commanding role in this crime partnership.

06 29 October 1939 Victim of Auto Accident.

By placing the steering wheel of the damaged vehicle in the corpse's hand, Weegee transforms what might be an otherwise routine picture of a traffic accident. In conjunction with the two speeding cars frozen in the background, it makes for a wry, if brutal, comment on man's destructive love affair with the automobile.

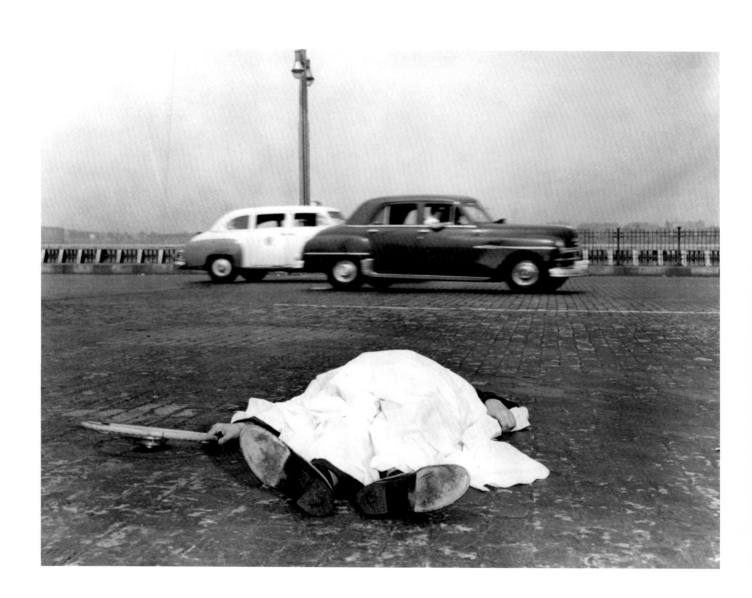

15 December 1939 Mrs Henrietta Torres and her Daughter Ada Watch as
Another Daughter and her Son Die in Fire.

Being raised in a tenement himself, Weegee said this image haunted him
for the rest of his life. After hearing a call on the police radio, he rushed
to the Puerto Rican district in Brooklyn. Weegee overheard a firefighter
say, in the deadening language that affords the necessary emotional
distance, 'It's a roast', indicating that someone had burned to death.
Amongst the crowd of relieved relatives and friends, Weegee saw this
grief-stricken mother and daughter. Looking up to the top floor of the
housing block, the mother still hopes; while, turning away from the
blaze, the daughter comprehends the bleak truth.

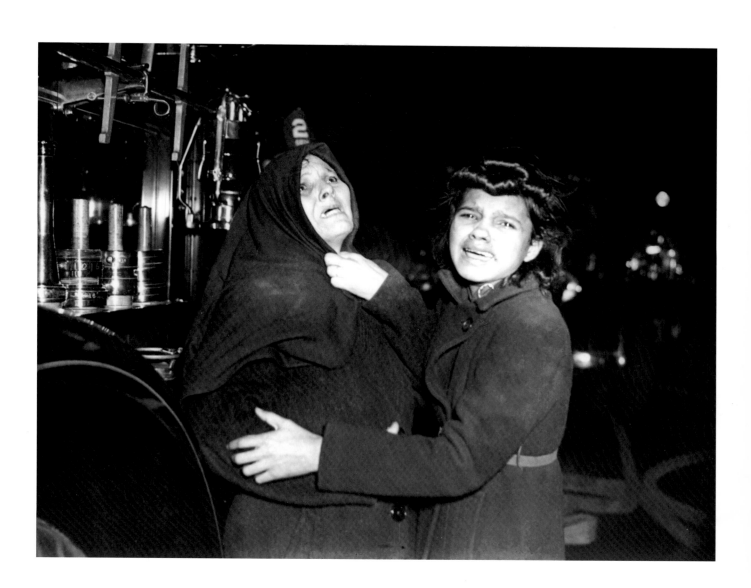

c. 1940 Easter Sunday in Harlem.

In his first book of photographs, *Naked City* (1945), Weegee wrote of this image, 'I spotted this happy man coming out of the church ... he told me that he was a clothing salesman ... and that every Easter Sunday he puts on his full dress suit.'

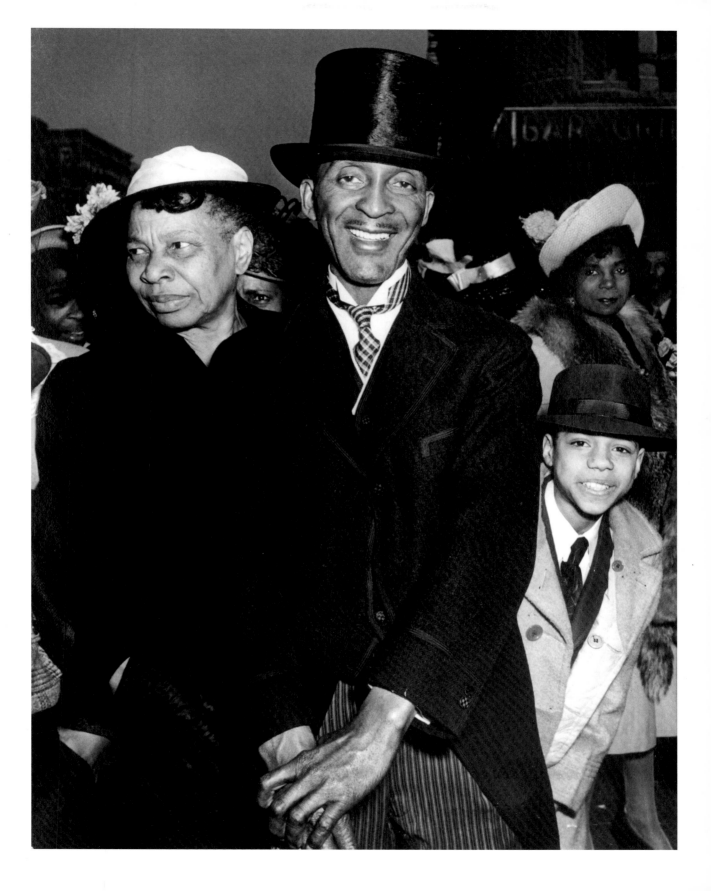

c. 1940 On the Spot.

Once again, Weegee utilizes a street sign as a ready-made caption for this
murder. A white blanket covers the dead victim, who lies spread-eagled on
the sidewalk. The casual demeanour of the police officers is unsettling.
While the man's blood collects in a pool in the gutter, the policemen line
up outside The Spot bar and grill, seemingly posing for Weegee's camera.

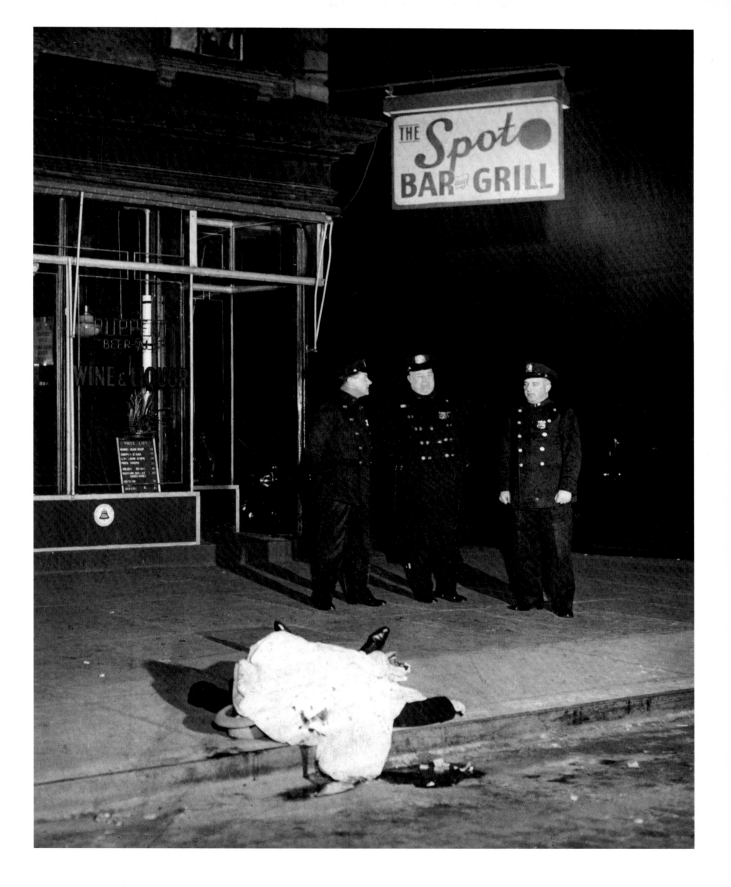

c. 1940 Max the Bagel Man.

The shadows and shifting planes of the night afford unlimited opportunities for the creative camera. Through the work of photographers such as Brassaï, Bill Brandt and André Kertész, a fascination with the nocturnal city has been a recurrent theme in the history of photography, documenting the hidden world of work (bakers, cleaners, policemen) or crime (gangsters, prostitution). Few photographers have chronicled the human traffic of these twilight happenings with such diligence and resolve as Weegee, who worked every night for more than a decade. In this image of a man delivering bagels, the night becomes as much a character as the individual depicted.

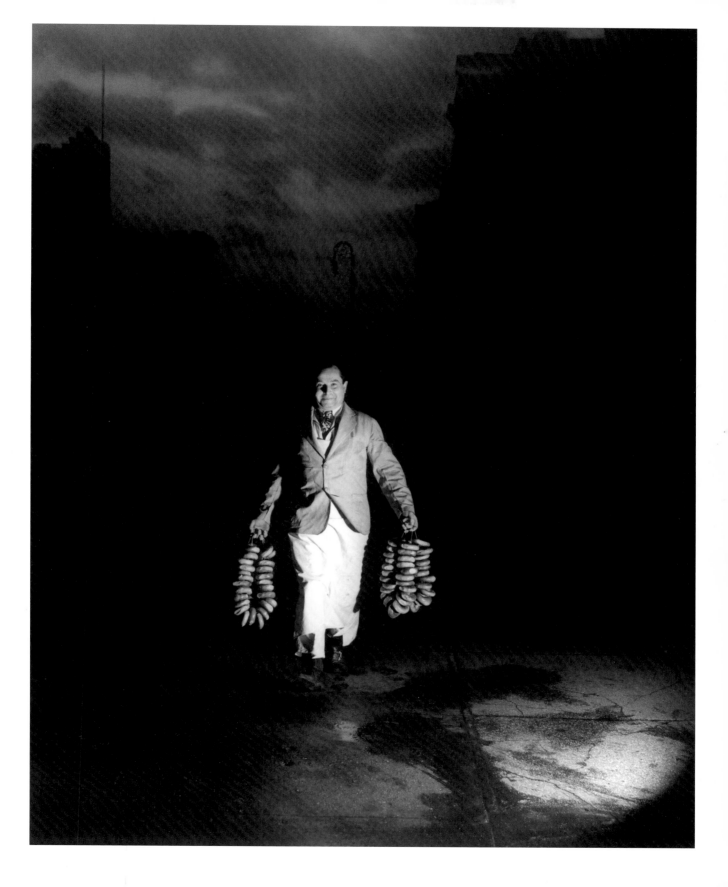

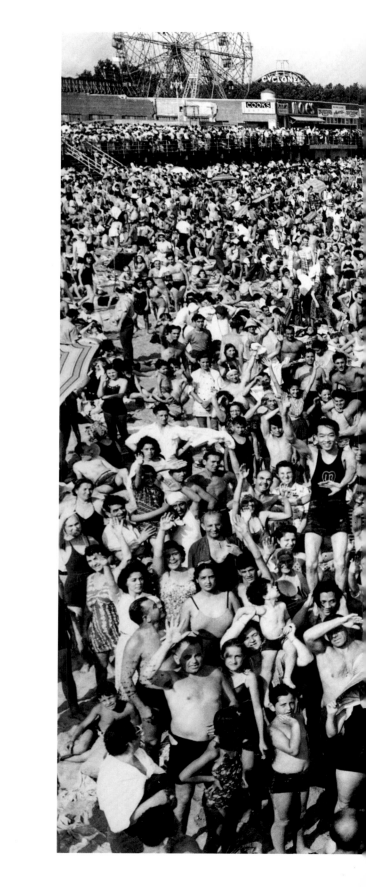

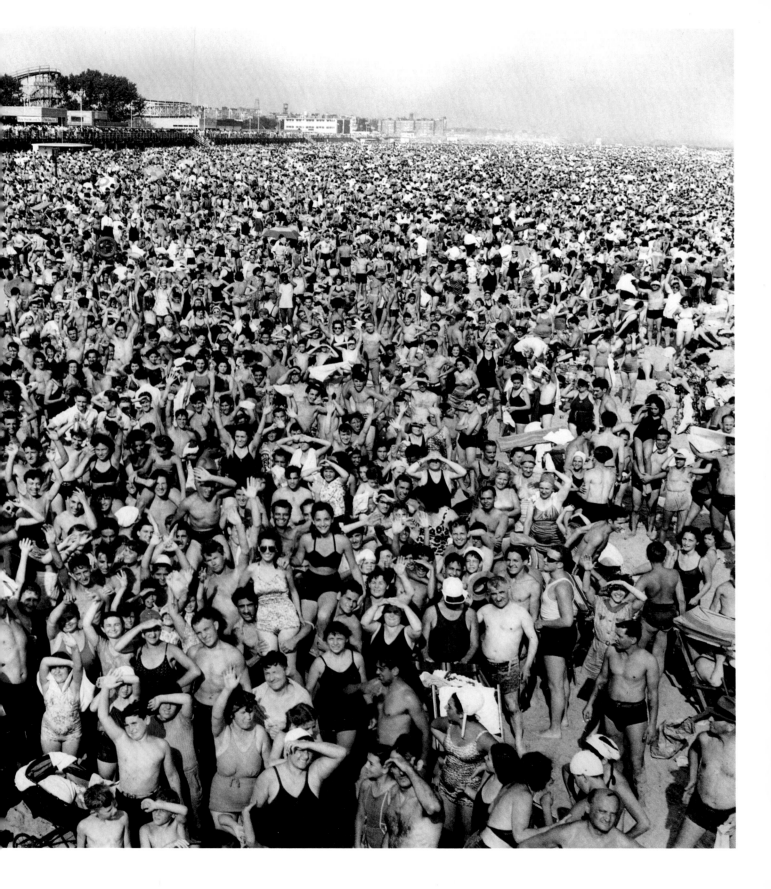

11 *previous page* 22 July 1940 Crowd at Coney Island, Temperature 89° ...
They Came Early, and Stayed Late.

For only a nickel, many New Yorkers would escape the oppressive heat of the city by taking the subway to Coney Island. On this particular Sunday afternoon, the city seems to have made the journey en masse. Weegee's photograph for the newspaper *PM* captures the immense, sweltering crowds, estimated at more than a million, stretching out beyond the horizon. It was one of his most famous images, and Weegee repeated it on several occasions. Each time his method seems to have been the same. Waving and shouting to attract the crowd's attention, he would wait until the decisive moment, then take the shot. Unlike his other attempts, this image stands apart through the sheer number of people he caught gazing into his camera.

12 c. 1941 Dead on Arrival.

Corruption was a pervasive feature of New York City in the 1940s and Weegee was its chronicler. In his 1944 essay 'The Simple Art of Murder', the pulp crime novelist Raymond Chandler offered a concise overview of Weegee's world, where 'a judge with a cellar full of bootleg liquor can send a man to jail for having a pint in his pocket, where the mayor of your town may have condoned murder as an instrument of money-making, where no man can walk down a dark street in safety because law and order are things we talk about but refrain from practising; a world where you may witness a hold-up in broad daylight and see who did it, but you will fade quickly back into the crowd rather than tell anyone, because the hold-up men may have friends with long guns, or the police might not like your testimony.' Like a piece of luggage left in the gutter, this blood-splattered corpse, caught in Weegee's flash, has been tagged by the police 'DOA', meaning 'Dead on Arrival'.

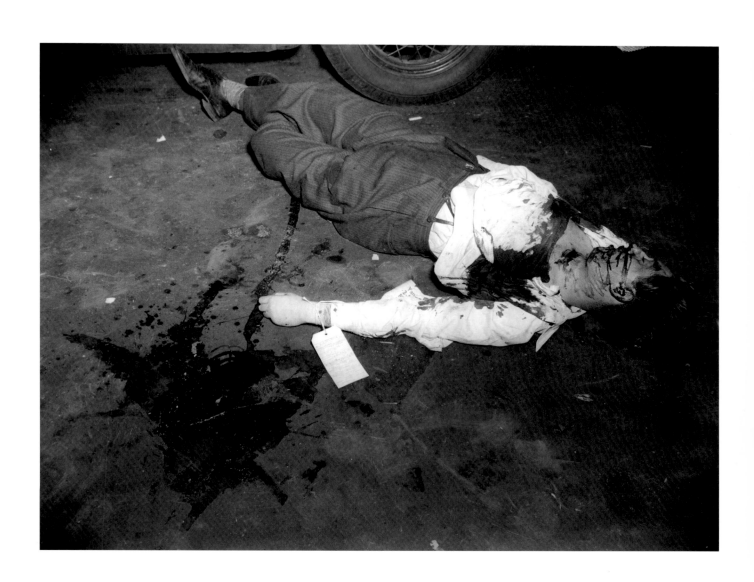

| 13 | 16 January 1941 | Cop Killer. |

Framed by the broad backs of two detectives, the bruised and battered man in the centre is Anthony Esposito. Arrested for the murder of a businessman and a police officer, Esposito is having his mug shot taken by the police photographer. What is striking about this image is the absence of distance between viewer and subject. In contrast to the tableau style of his outdoor work, the light from Weegee's flash produces an iris effect in this enclosed space. The result is a converging of perspective: the oppressive darkness of the line-up room envelops the viewer, conveying the brooding violence just below the surface.

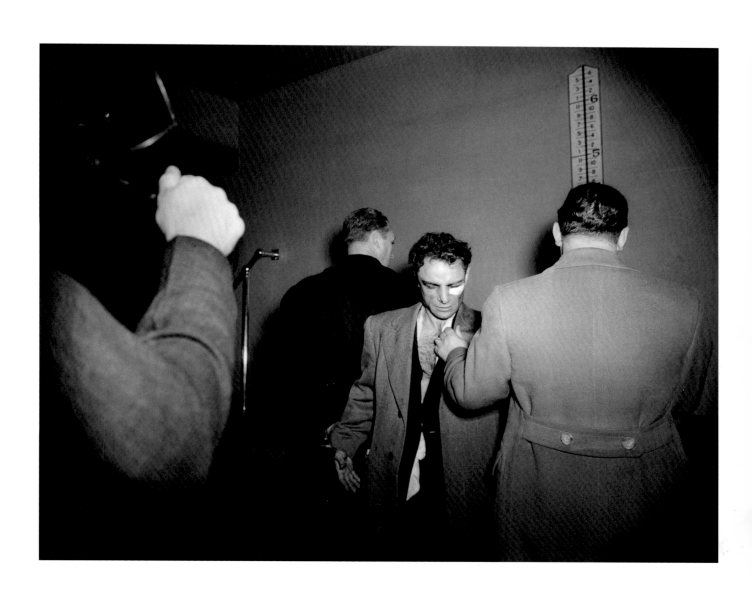

23 'May 1941 Heat Spell.

This picture was featured in a 1944 exhibition of Weegee's work at the Museum of Modern Art, New York. In his autobiography, *Weegee by Weegee* (1961), Weegee recounted that some members of the public wished to discover how he knew that people slept on the fire escape. He simply informed them that it was how he had slept as a child.

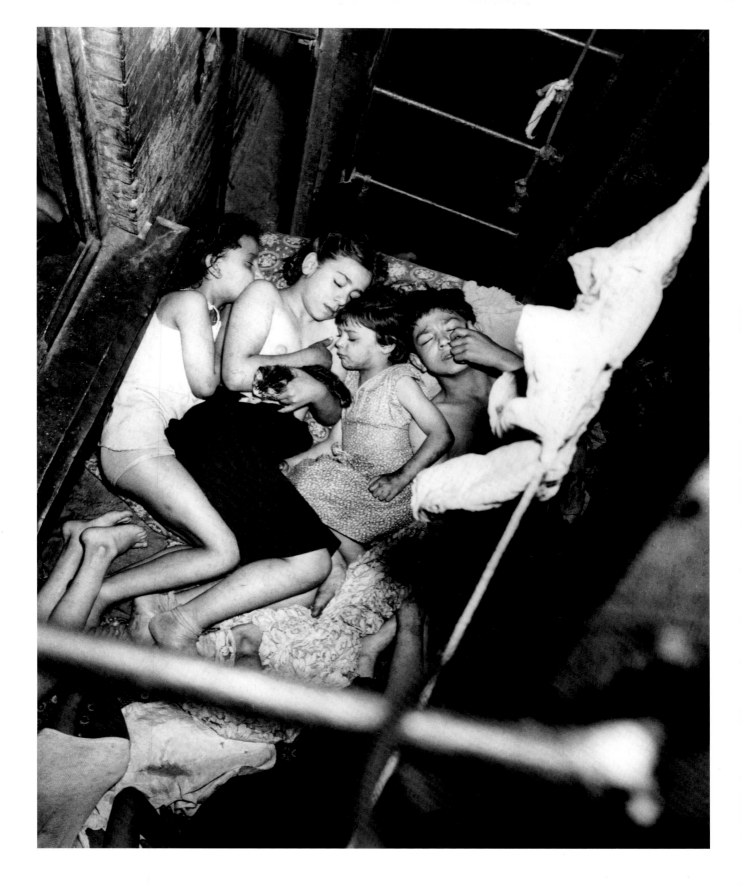

15 9 June 1941 Lost Children.

Cavorting along the boardwalk or enjoying rides such as the famous
Cyclone rollercoaster, children often became separated from their
parents among the crowds at Coney Island. This picture was taken on
the opening weekend of the summer season. Arriving early, Weegee's
aim was to secure an image of the first child delivered to the Lost
Children shelter. Not long after this photograph was taken, the child's
frantic mother arrived to collect him.

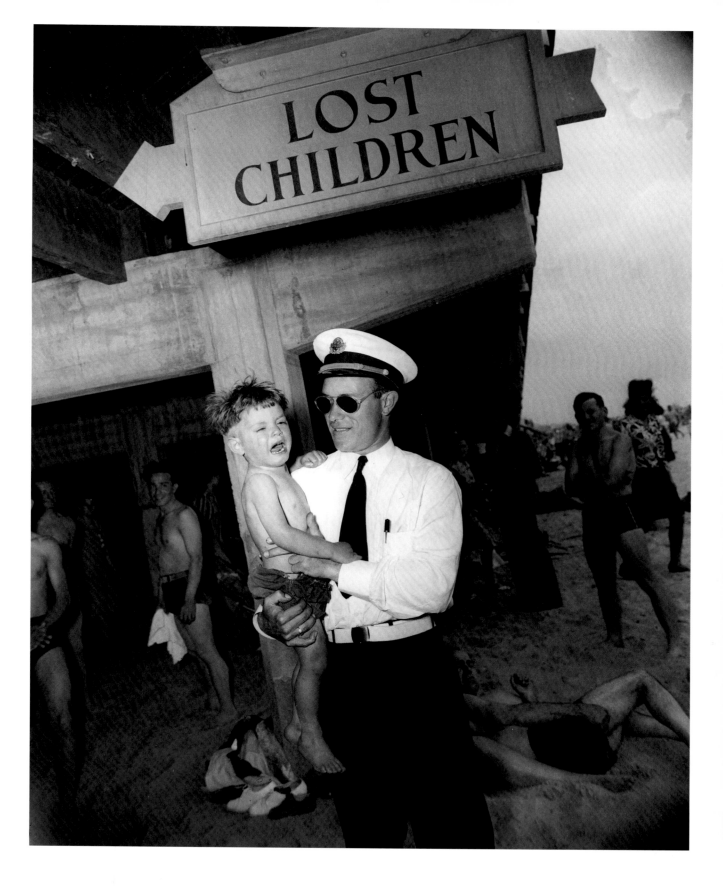

13 July 1941 Car Crash, Upper Fifth Avenue.

Documenting events beyond his or her control, the news photo-
grapher appropriates whatever compositional device is on hand. In
this photograph, Weegee utilizes the window of a car door to frame
the casualty and his friend. One unsettling aspect of this photograph
is the reflection of the victim in the side window. This cropped
mirror image, as a portentous signifier of his prospects for survival,
is resonant of a corpse in an open casket.

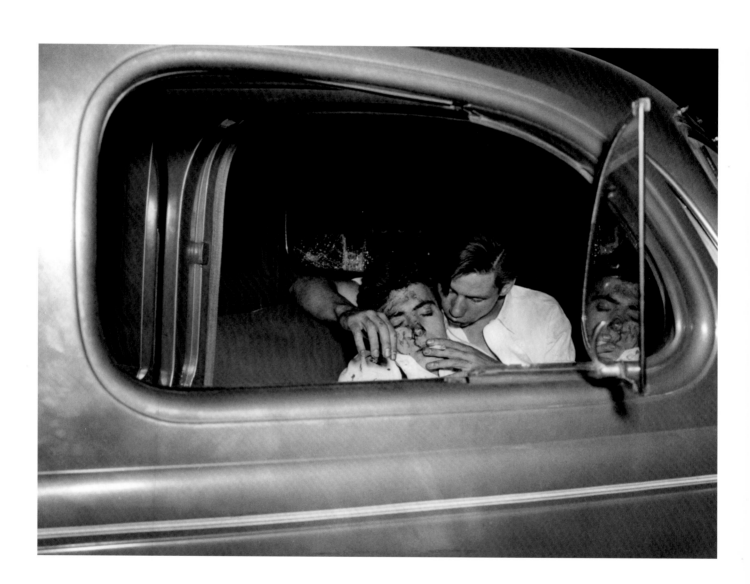

17 28 July 1941 Henry Geller Weeps Over Loss of his Tobacco Shop.

This photograph was taken on East Houston Street, Lower East Side. The neighbourhood of Weegee's teenage years, the Lower East Side was the setting for some of his most famous photographs. Throughout his life, Weegee had a profound respect for the hundreds of thousands of immigrants who occupied this densely populated district of Manhattan. He knew that the aspirations of most immigrants were simple: to obtain a regular income or, even better, to set up a family business. Weegee's photograph of the shopkeeper, suffering and tormented as his livelihood goes up in flames, is a powerful illustration of the loss of these hopes and dreams.

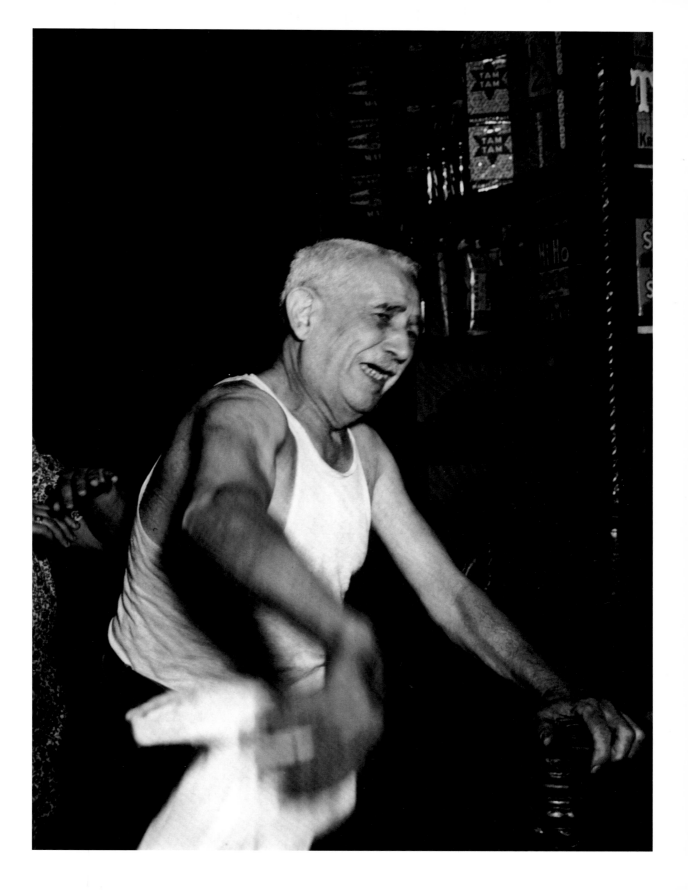

30 July 1941 Helping the Wounded.

The outcome of an argument between two men over Manuelda Hernandez (the woman seen here holding the wounded man), this image is a characteristic example of how the tabloid audience was made party to an unfolding drama. In a composition that resonates with semi-religious overtones, Weegee strikes a delicate balance between the required immediacy and a formalistic distance. The caption to the image, which was featured in the newspaper *PM*, noted how the police were desperate to lift the man on to a stretcher, but the distraught Hernandez refused to let go of him.

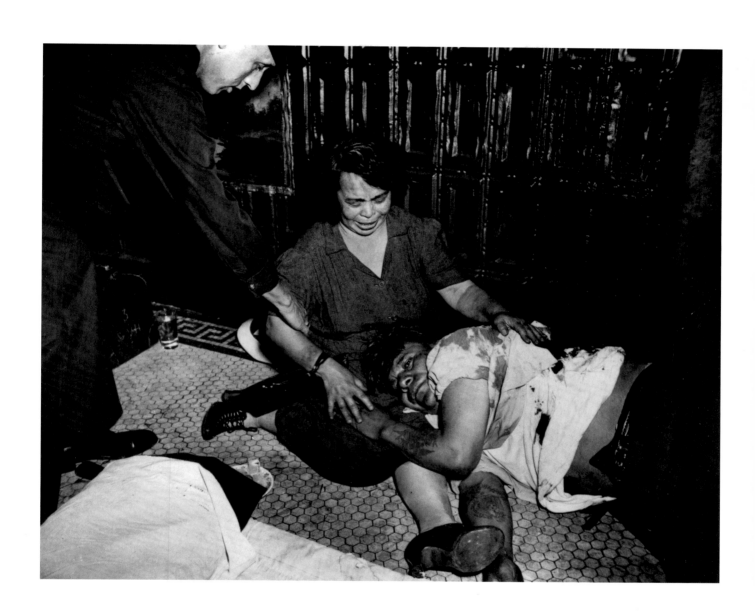

9 October 1941 Their First Murder.

In his youth, Weegee would occasionally play the fiddle at cinemas. Complementing the dramatic scenes of a silent movie, he loved to play on the emotions of the audience. In his autobiography, Weegee declared that his fiddle playing was probably 'a subconscious kind of training for my future photography'. Capturing the aftermath of an underworld murder, this single image incorporates the range of emotions one would normally ascribe to an entire film. The older woman at the centre of the picture is the aunt of the victim. Her son is pushing the girl out of the way in order to free his grieving mother from the frenzied crowd of spectators.

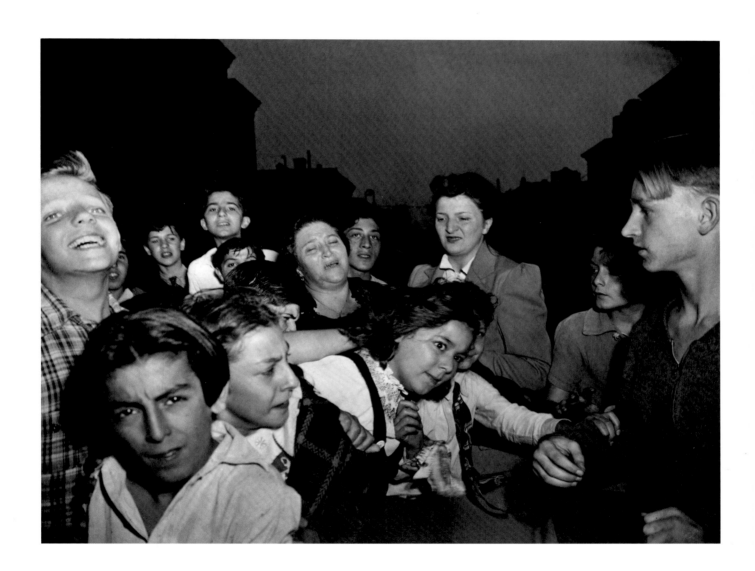

15 October 1941 | What to Wear.

This man was awakened in the night when he smelled smoke coming from the apartment below him. Before fleeing the fire, he alerted the other tenants in the building who were all evacuated unscathed. What is astonishing about this image is how Weegee managed to arrive at the scene in time to capture the man vacating the building. Flitting down the stairway, clutching his trousers, the tenant's face shows a mixture of joy and relief at his narrow escape.

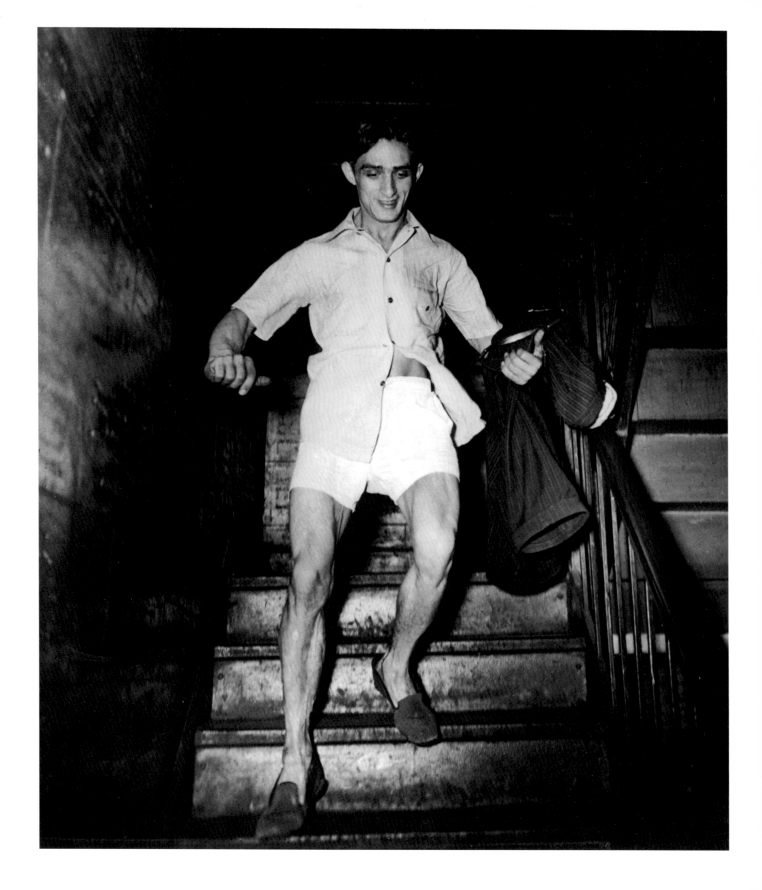

c. 1942 This Boy Got his Hand Caught in the Cup Machine.

Initially, this photograph seems to depict a policeman arresting a young offender. On closer inspection, the cop with his arm around the boy's shoulders seems rather protective towards the young felon. Is he actually the boy's father? What is clear is that the boy has been caught in the act of stealing. A strong hand from the left of the picture holds the boy's arm. The boy displays his injured thumb for Weegee's camera as if it were a piece of evidence.

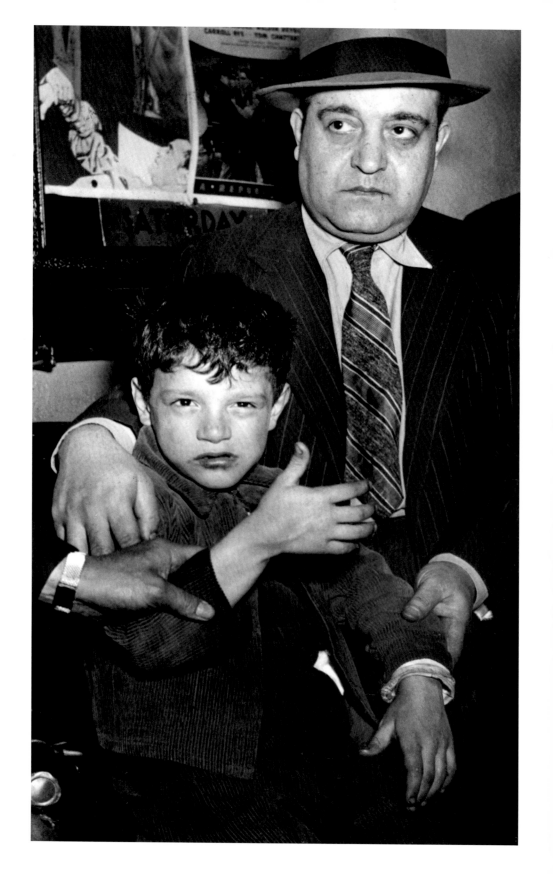

22 c. 1942 Waiting in Line for the Night Judge.

From the breaking news of a crime to the successful arrest and the concluding spectacle of trial and prosecution, the tabloids manufactured compelling narratives that were comparable to plots from a Hollywood melodrama. Akin to watching a film, the reader would experience the full gamut of emotions as a story developed. Weegee's composition of this nighttime arrest lends itself perfectly to the sensation of actually watching an event unfold. In what is a revealingly self-referential moment, he captures both the photographer and the photographed in a single shot. Through this device, he acknowledges his own dual role as both chronicler and storyteller.

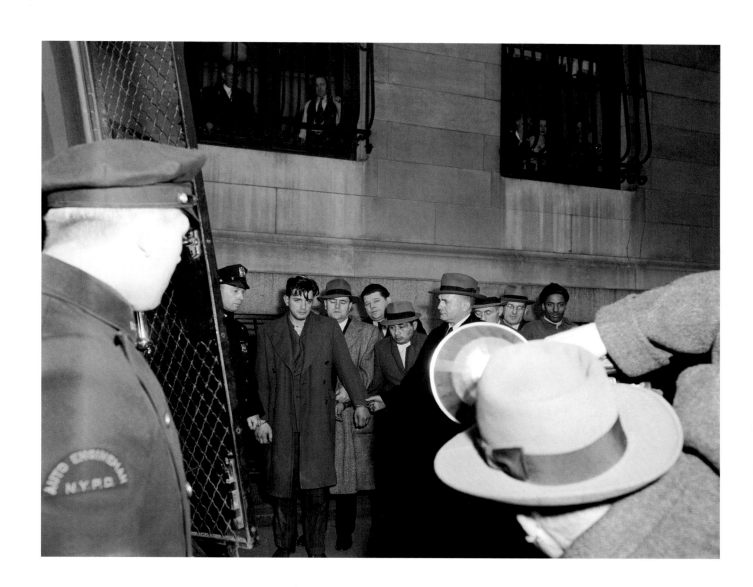

23 27 January 1942 Charles Sodokoff and Arthur Webber Use their Top Hats
to Hide their Faces.

Weegee was always conscious of how his pictures would look on the page.
The strength of this photograph resides in its pure, graphic simplicity.
Through a combination of the white wall of the police wagon, the black
evening wear and the pale hands holding the top hats, Weegee produces a
stunning image without any artistic affectation or pretence.

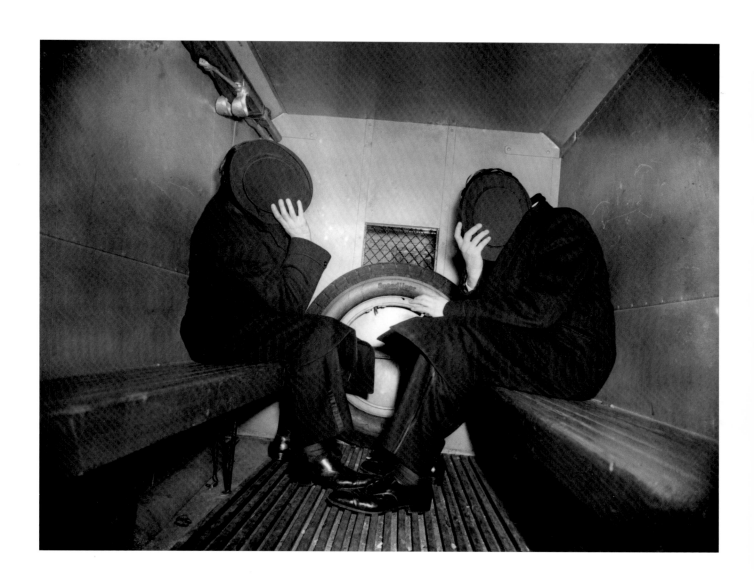

3 February 1942 Gunman Killed by Off-Duty Cop at 34 Broome Street.

This hapless gunman attempted to rob a store in which an off-duty cop was buying a packet of cigarettes. Capturing the armed robber's gruesome demise, the brutal luminosity of Weegee's flash is in perfect synthesis with the subject matter. The unrelenting light accentuates the hardness of the grey sidewalk, lucidly delineating the gunman's bloody face.

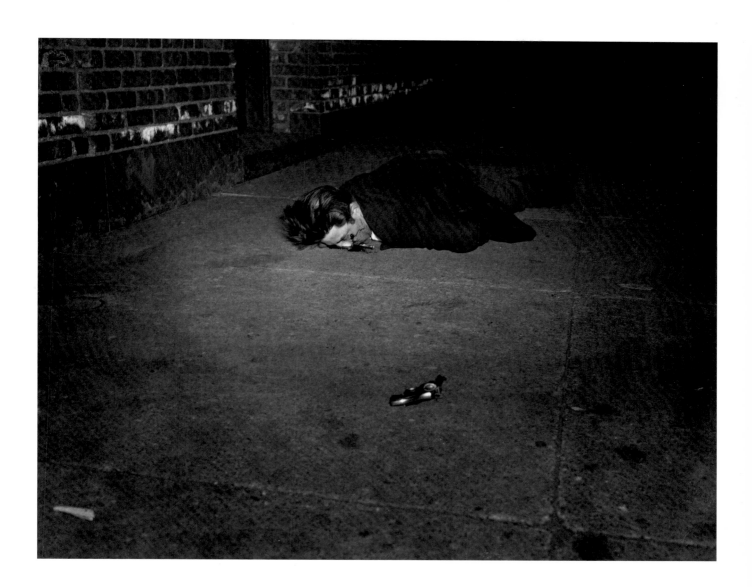

By the 1940s, the automobile had become a ubiquitous feature of modern American life. It shaped ordinary day-to-day activities from the increased freedom to travel to the growth of the suburbs. However, the meagre array of legislation that served to regulate this growth had failed to keep pace with the associated problems of speeding and drunk driving. With road traffic accidents a daily occurrence, Weegee was not short of material. On this cold winter's night, his camera captures a police sergeant watching a black Buick being hoisted out of the river. The sergeant witnessed the accident himself. He appears to be pointing to the deceased driver of the car, whose protruding feet can just be seen through the windscreen.

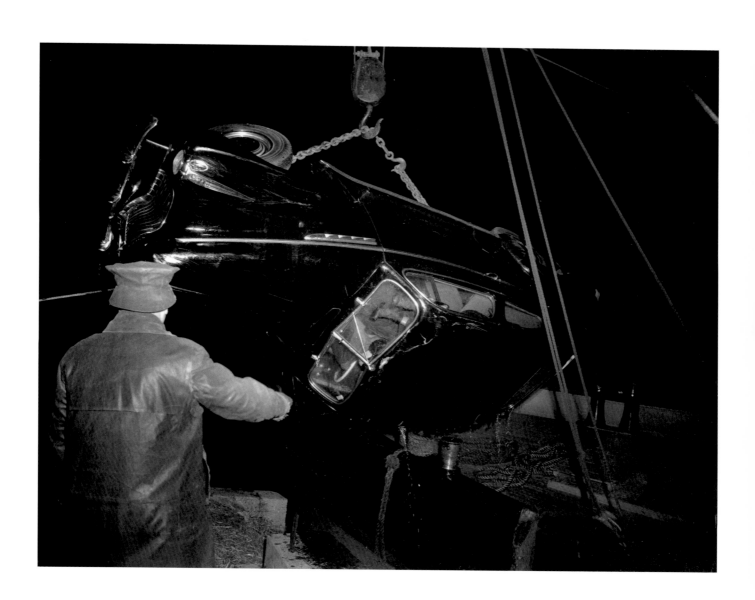

17 April 1942 Joy of Living.

The high-key tone lighting of crime and gangster films, such as *Double Indemnity* (1944), *Murder My Sweet* (1945) and *Kiss of Death* (1947), was clearly influenced by the stylistic qualities of Weegee's photography. In this picture of a victim of an automobile accident, the cinematic link is more explicit. Exploiting the billboard announcing Tay Garnett's 1938 film *The Joy of Living*, Weegee frames the incident so the film's title becomes a sardonic comment on the lifeless body below it.

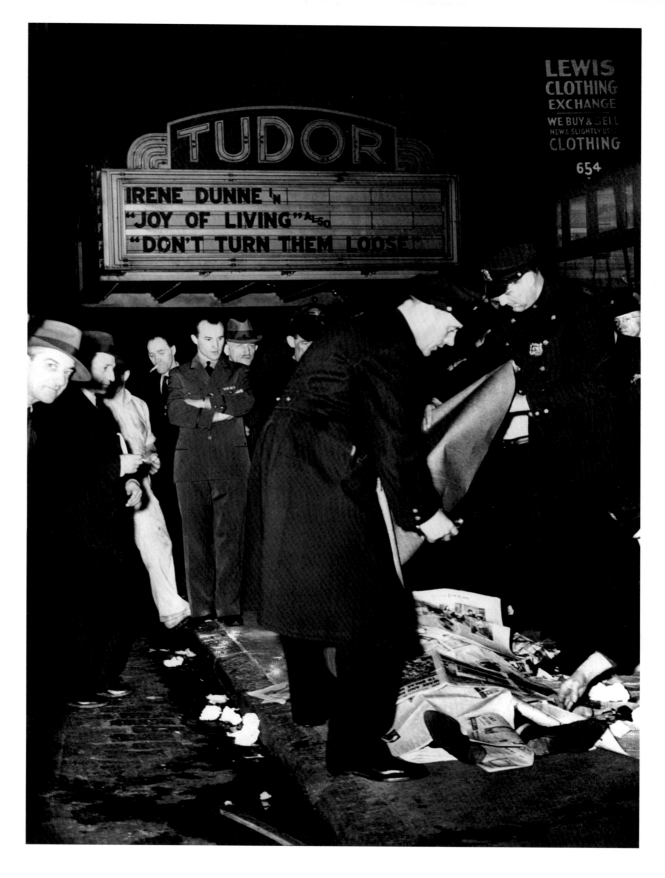

'Down With The Japs The Rats'.

By October 1942, the United States had been at war with Japan for just over ten months. Since the opening attack on Pearl Harbor, posters, badges, and numerous articles and cartoons in the national newspapers had stoked anti-Japanese sentiments throughout the United States. In the year this photograph was taken, more than 100,000 Japanese-Americans had been interned in war camps, on the basis that they posed a threat to national security. In this atmosphere of fear and prejudice, Weegee captures an impromptu anti-Japan demonstration by children on the Lower East Side. The image contains disturbing and sinister undertones, presaging the spying children featured in George Orwell's novel *1984* (1949). Wearing his brother's army coat and cap, the child in the centre of the picture offers Weegee a toothless grin.

28 31 December 1942 'Shorty', the Bowery Cherub, New Year's Eve at Sammy's Bar.

The seedy allure of Sammy's was a draw for many photographers. In 1944, for instance, Lisette Model produced a series of images of the club for the magazine *Harper's Bazaar*. Yet Sammy's was more than just an exotic subject for Weegee: it was a regular haunt, a place where he shared a common background with most of the locals. He even held the launch party for *Naked City* at the club, and Sammy himself bought a thousand dollars' worth of books (*Weegee on Weegee*). Another regular at Sammy's was 'Shorty', seen here celebrating New Year's Eve.

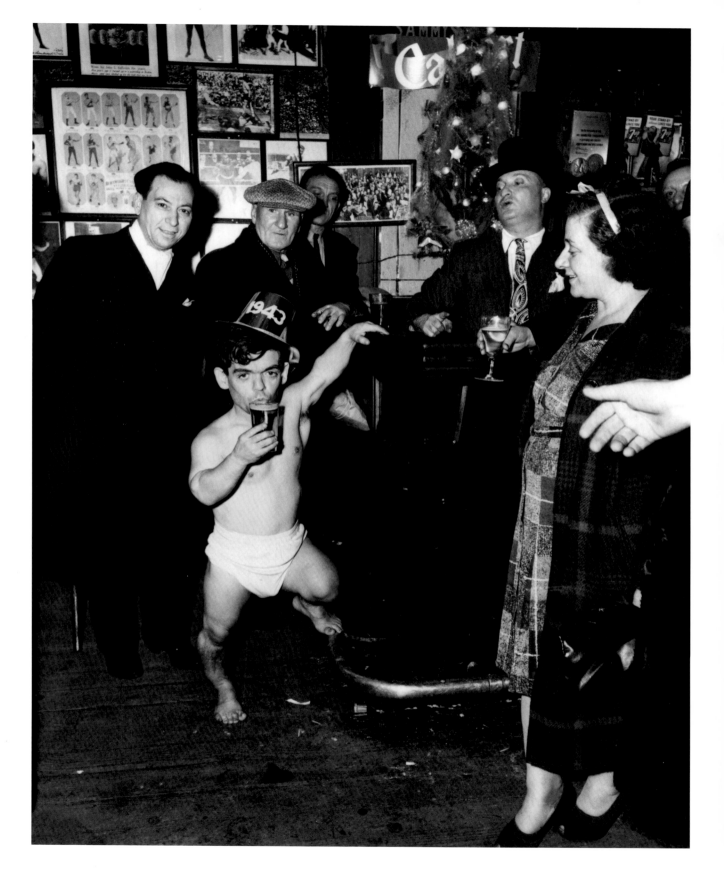

c. 1943 Masquerade Ball.

The mask of Stalin, in the midst of this ball at the Waldorf Astoria Hotel, serves as both a moment of light relief and a reminder of the war then raging in Europe. However, the hand seen at the bottom left-hand corner of the photo shows that not all the party-goers were happy to be snapped by Weegee's camera. Helen Gee noted such responses to Weegee's presence in her memoir *Limelight* (1997). Documenting her life in the late 1950s, when Gee ran a coffeehouse and the first photography gallery in the United States, she recalled that Weegee 'didn't appear often, but when he did, there were complaints. He would roam around the room, popping off flashguns in customers' faces, and scowl and mutter when they protested. He'd go from table to table handing out greasy name cards, rubber stamped with his logo.'

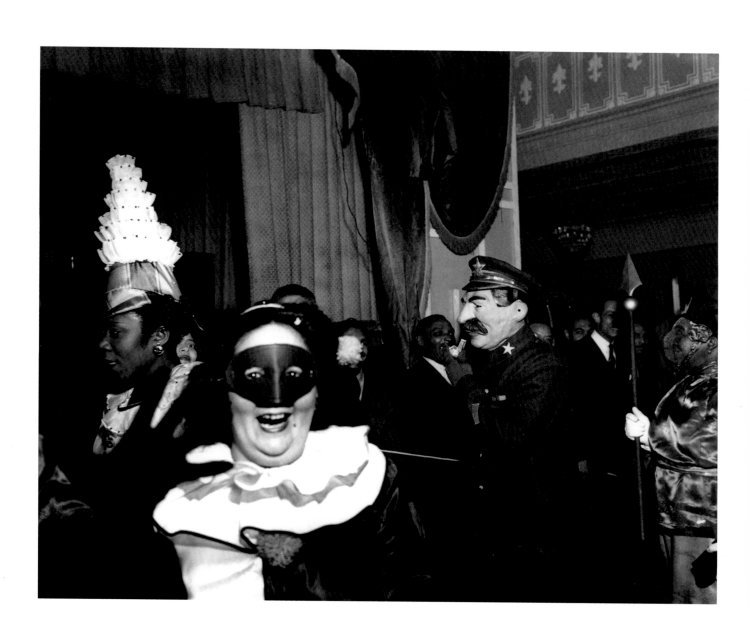

　　　　　c. 1943　　Sammy and Guests.

No. 267 on the Bowery was a place that Weegee referred to as 'the poor man's Stork Club' (*Naked City*). Opened in 1934, Sammy's on the Bowery was Weegee's nightly refuge from the numerous horrors he witnessed in his exhaustive pursuit of that exclusive picture. Mainly frequented by local characters from the neighbourhood, it also drew an uptown crowd on the lookout for an 'authentic', gritty late-night club. The owner, Sammy Fuchs, can be seen smiling at Weegee, as he snaps this picture of an attractive young woman.

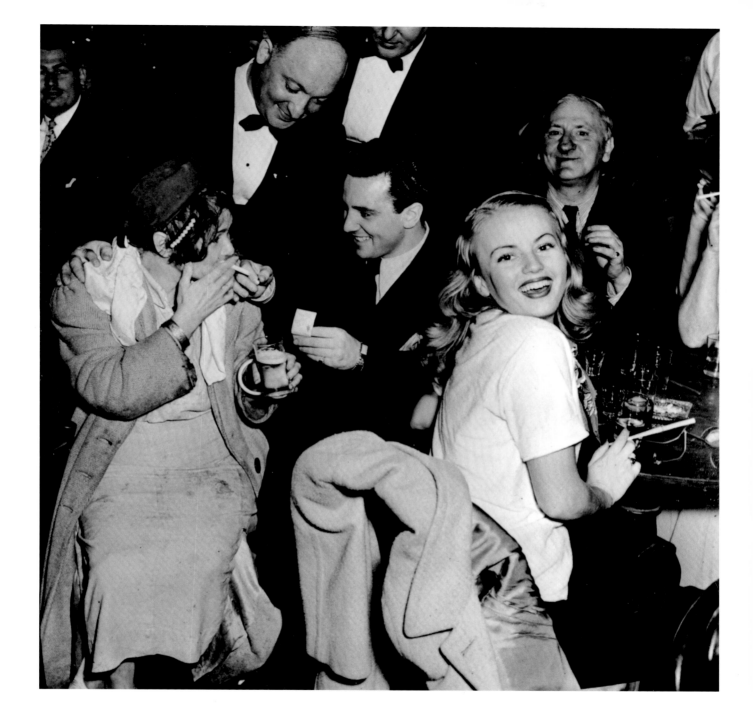

31 c. 1943 Girls Watching Movie.

In possession of infrared film and flash, and occasionally disguised as an
ice-cream seller, Weegee was commissioned to produce a whole series of
images of cinema-goers, bewitched by events on the silver screen. Of all
these images, his pictures of children are perhaps the most striking.
Weegee captured many youngsters in various states of elation, laughter or
boredom, watching such films as *Fantasia* (1940), *Buck Rogers* (1939) and
Lassie Come Home (1943). In this photograph, taken at the Palace Theatre
on Broadway, Weegee captured a scene where many emotions are expressed
in a single moment. Seemingly unimpressed by the film, one girl blows
bubblegum, while another has fallen asleep.

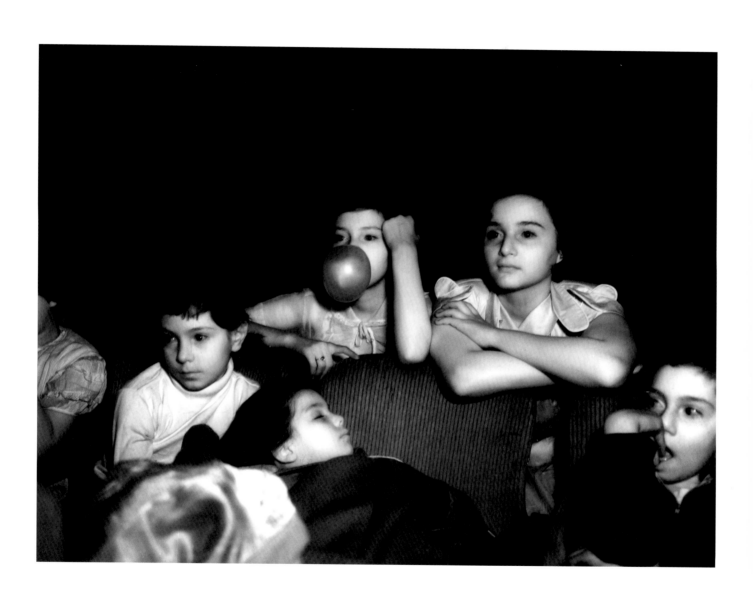

c. 1943 Lovers on the Sand.

Aside from such photographic luminaries as W. Eugene Smith, Weegee was singularly unimpressed by the work of many of his contemporaries. However, over the decades, many photographers have employed Weegee's Coney Island images as the starting point for their own projects on the resort. For example, striking echoes of this photograph can be found in the work of both Bruce Davidson and Robert Frank.

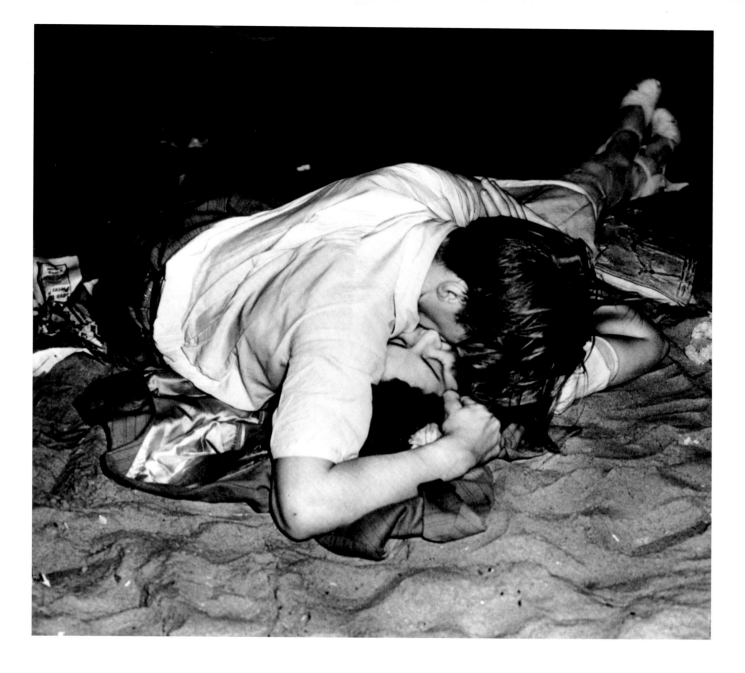

33 c. 1943 She's Got the SPIRIT!

Sparked by news that a white policeman had shot a black serviceman, the
district of Harlem was rocked by a two-day riot on 1 and 2 August 1943.
In response to these disturbances, local people came together to foster a
stronger community spirit. The main focal points of these gatherings
were the local churches. Most probably photographed at the Abyssinian
Baptist Church, Weegee's image of this elderly woman singing a spiritual
song captures a brief moment of relief from the troubling events in the
neighbourhood. Supported by those around her, the woman reels back,
lost in the fervour of the psalm.

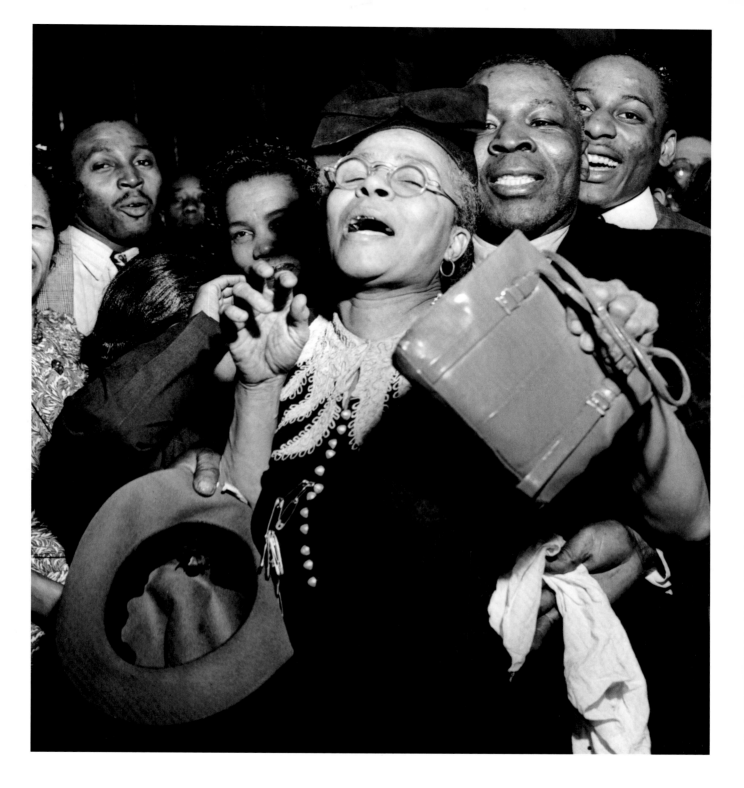

June 1943 Tenement Sleeping.

Some commentators on Weegee's work have questioned the ethics of his decision to bring private and intimate events of everyday life into the public sphere. Such criticisms neglect Weegee's experience of growing up in the overcrowded district of the Lower East Side. For generations of immigrants, all having to share the same confined space of a two-room apartment, questions of privacy were a luxury they could not afford. As with this man, on hot summer evenings many would escape their cramped bedrooms and the oppressive heat of their apartment to sleep outdoors.

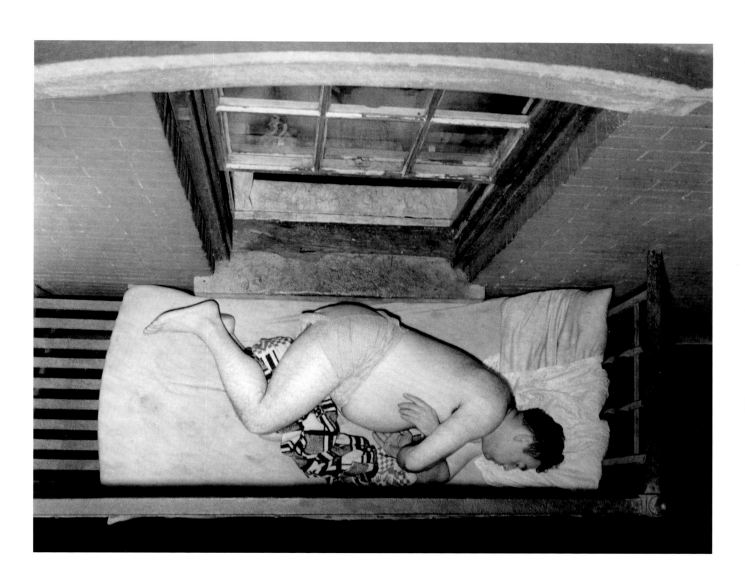

16 August 1943 Boys Caught in Boarded-Up Harlem Store.

The riots that took place in Harlem in 1943 resulted in six deaths, thousands of injuries and more than five million dollars' worth of damage to local businesses. Following these upheavals, many stores in Harlem were beyond repair or simply boarded-up. During the long muggy summer of 1943, it must have been irresistible for local children on vacation to explore these riot-wrecked stores. In this image, Weegee photographed three boys who were caught in a vandalized drug store on 145th Street and 8th Avenue. According to the caption to the picture in *PM*, the boys were subsequently taken to the 135th Street Station House, where they handed over their 'loot' of Bull Durham tobacco.

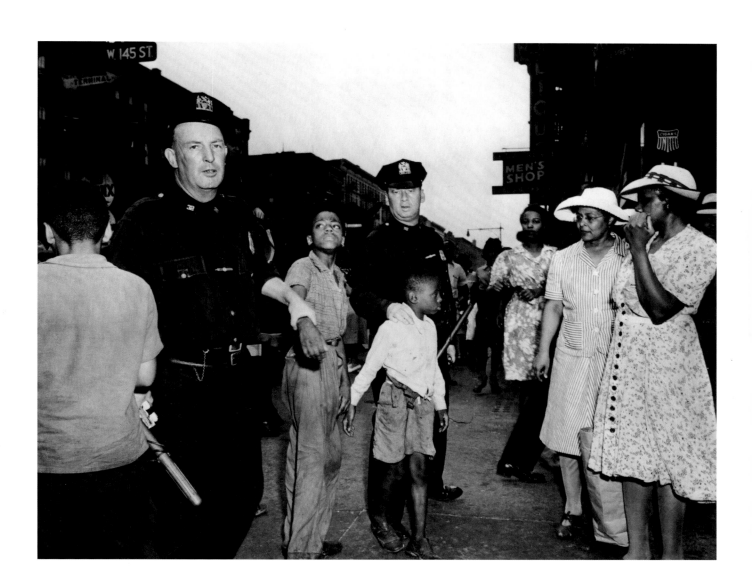

24 August 1943 | Ambulance Plunges Bringing Death to Two.

Weegee's daytime use of his flashgun lends this scene of a grisly salvage operation a hyper-real quality. By accentuating the silvery metallic lights and radiator grill of the ambulance, the white T-shirt of the boatman and the deathly pallid body of the victim, his flash imparts a sinister quality to the inky black water.

26 November 1943 Meet Myrtle from Myrtle Street.

After an unsuccessful night's work, Weegee was always guaranteed photo opportunities with the arrival of the 'Pie' wagon. As he recounted in *Naked City*, 'Every morning the night's "catch" of persons arrested is brought down from different police stations to Manhattan Police Headquarters where they are booked for the various crimes ... the parade never ceases as the "Pie" wagon unloads.' With previous convictions for burglary and petty larceny, the man pictured smiling for Weegee's camera was arrested for dressing as a woman.

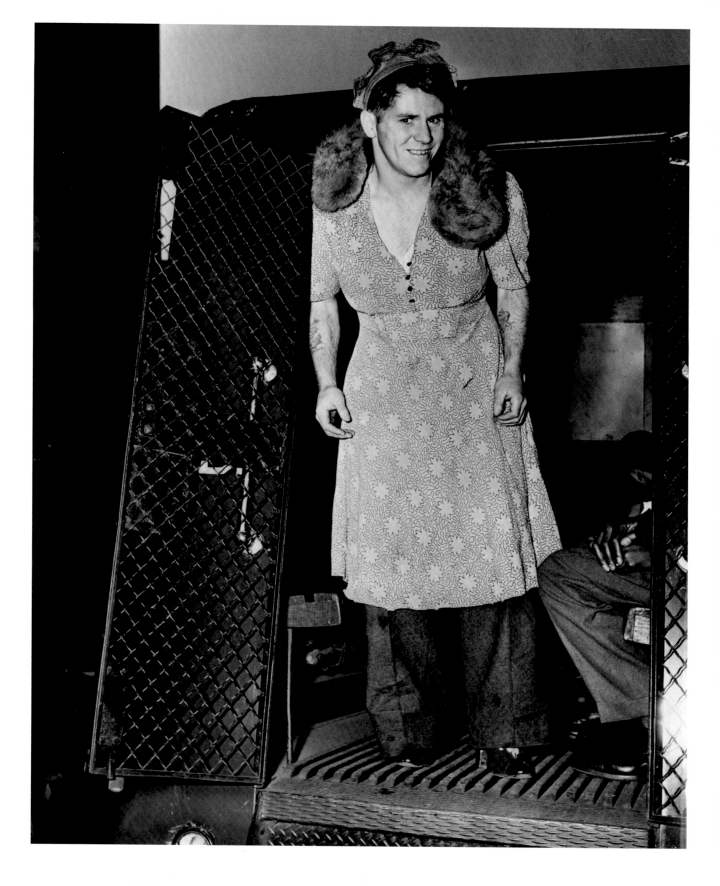

6 December 1943 The Critic.

This is Weegee's most reproduced image and he believed it marked a turning
point in his career. He wrote in *Naked City* that while covering an opening
night of the Metropolitan Opera, New York, he saw a Rolls Royce pull up,
and when two ladies (Mrs George Washington Kavenaugh and Lady Decies)
stepped out he just snapped them. It is hard to believe Weegee's story that
he only saw the dishevelled woman casting her critical eye when he began
to print the photograph in his darkroom. Indeed, Weegee's assistant Louie
Liotta claimed that Weegee asked him to find a regular from Sammy's,
furnish her with cheap wine, and bring her to the opera house. Weegee gave
the signal to Liotta to release the woman as the two ladies approached him.
Originally produced for *PM*, the newspaper decided against publication on
the grounds that such opulent evening dress was incongruous with wartime
austerity. It eventually appeared in *Life* magazine.

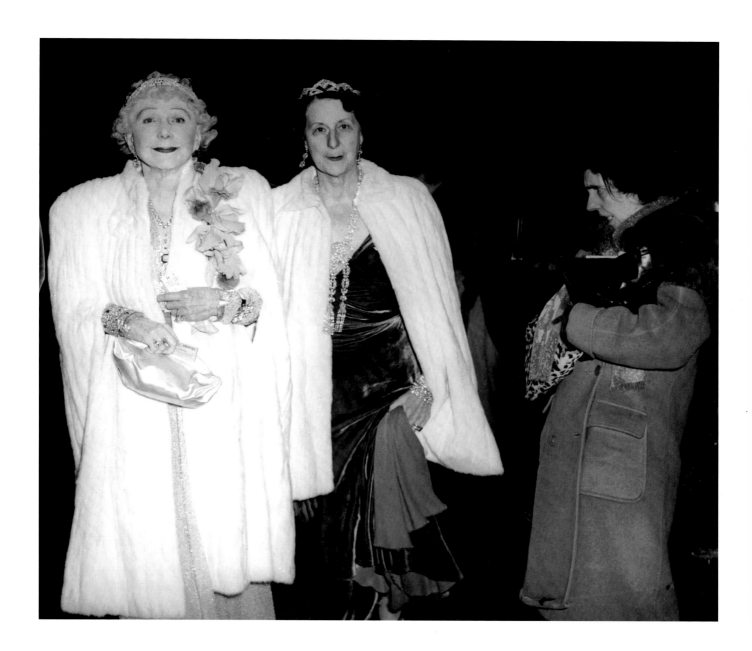

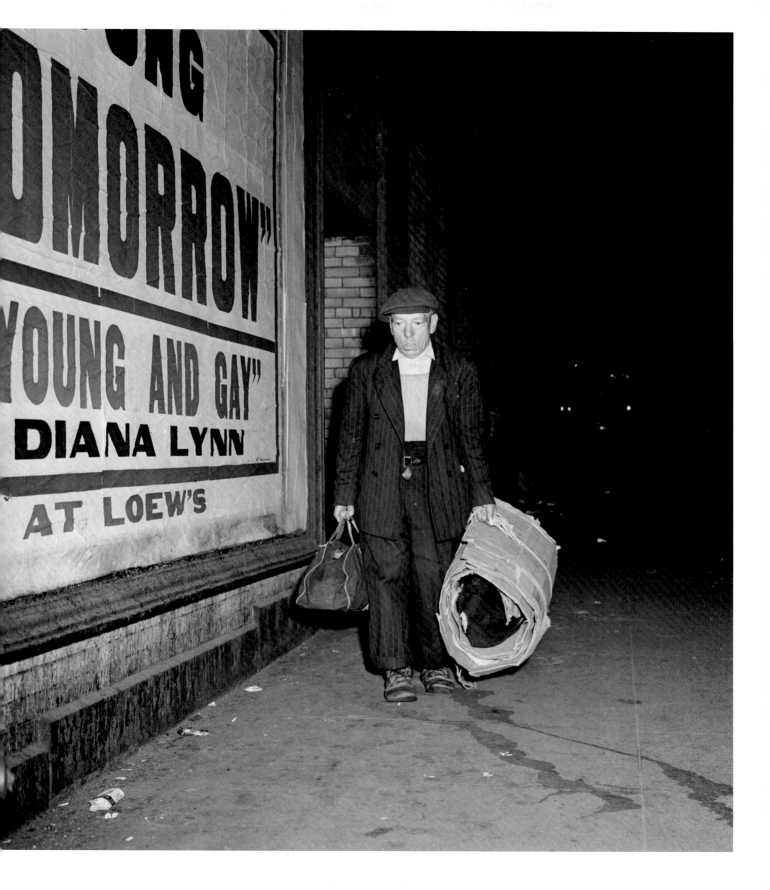

The Depression of the 1930s left millions of people unemployed and homeless. Like the down-and-out pictured here, Weegee knew what it was like to be destitute. Leaving home at the age of eighteen, he was soon broke and hungry. Spending all day looking for work, in the evening he would sleep rough in parks, missions or dosshouses. Hardened by these dismal experiences, Weegee could not resist the bitter irony of a ready-made 'caption' that is in sharp contrast to the life of a passing vagrant.

Competing with hundreds of thousands of other day-trippers, searching for a spot on the beach is a time-consuming business. Once found, through the strategic placement of blankets, bags and picnic baskets, the patch of sand becomes a home for the day. To safeguard possessions, adults and children take turns to swim in the sea, while the unlucky one is sent on a long journey to buy sodas and hot dogs. On leave from the Navy, these sailors have staked their plot and are listening to baseball on the radio.

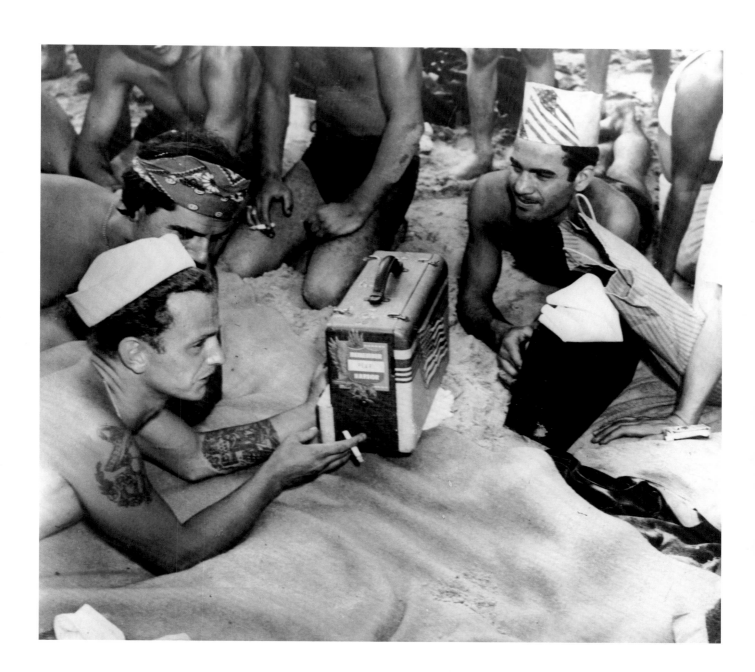

41 c. 1944 Wrong Way.

As they were offered numerous photographs of traffic accidents and collisions, tabloid editors could afford to be particular when procuring such images. In his constant attempts to stay one step ahead of the competition, Weegee would exploit anything at hand to catch the editor's eye. Even with this spectacular car crash on the roof of Grand Central Station, Weegee still chose to incorporate a one-way sign into the image to add a whimsical twist to the unfortunate episode. The caption to accompany this picture in the *New York Mirror* continued the humorous tenor, stating 'This car really took a "wrong turn" off Park Avenue.' The blur of the falling rain creates an impression of speed, as if the car is still moving.

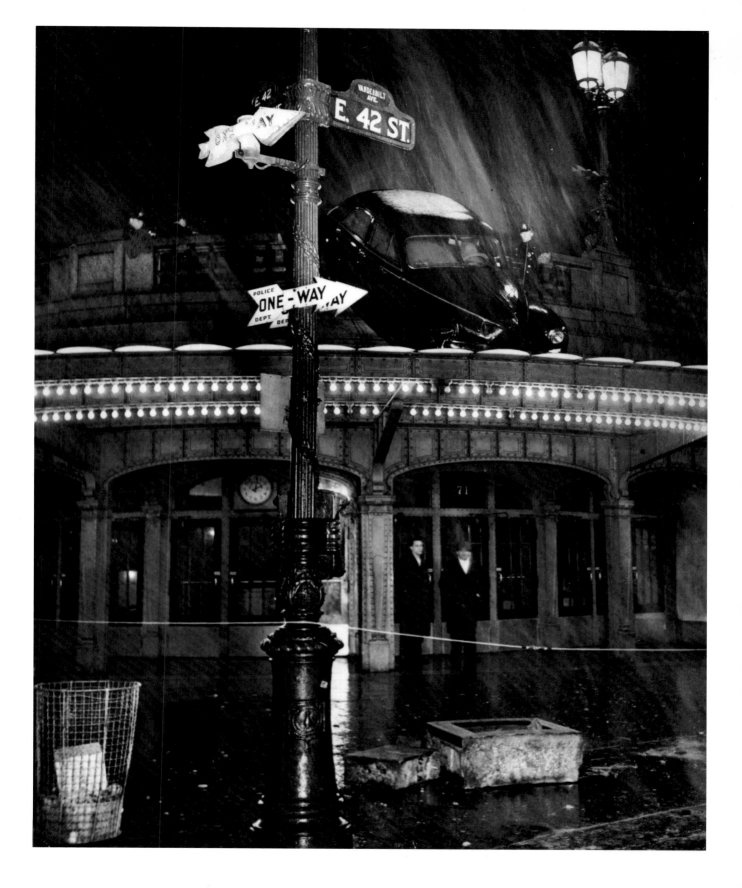

23 April 1944		A Couple Driven Out from the Burning Tenement.

Even when he was homeless, Weegee stressed the importance of owning a suit. You could lose your home and all your possessions, but having a suit would always help you find work. As Weegee remarked, 'One had to look neat, even if hungry, when job-hunting' (*Weegee by Weegee*). When faced with the decision of what to grab in the brief seconds before fleeing their apartment, this couple clearly concurred with Weegee's opinion.

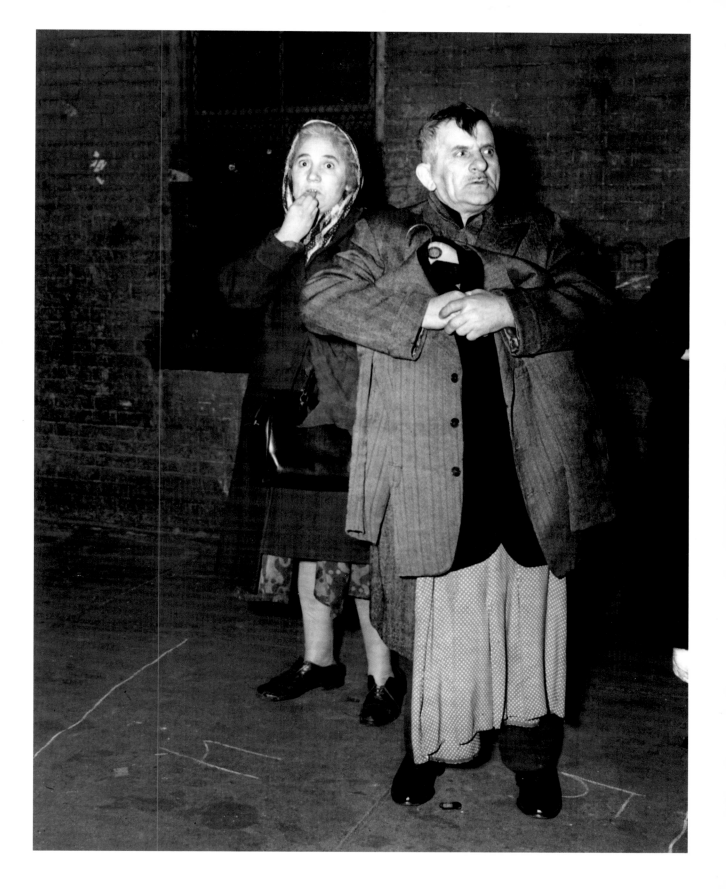

July 1944 Caffé Bella Napoli.

As Italian immigration into New York reached its peak during the second half of the nineteenth century, the desire to recreate the 'Old Country' resulted in the small self-contained enclave of 'Little Italy'. With numerous Italian cafés, restaurants, and even an Italian language newspaper, Mulberry Street lay at the heart of this district. Weegee's photograph captures members of this extended community, escaping their cramped apartments on a hot summer's day and gathering to talk at the Caffé Bella Napoli. The subject of conversation is most probably the continuing war in Europe, with each customer anxious for any news of family and friends in their homeland.

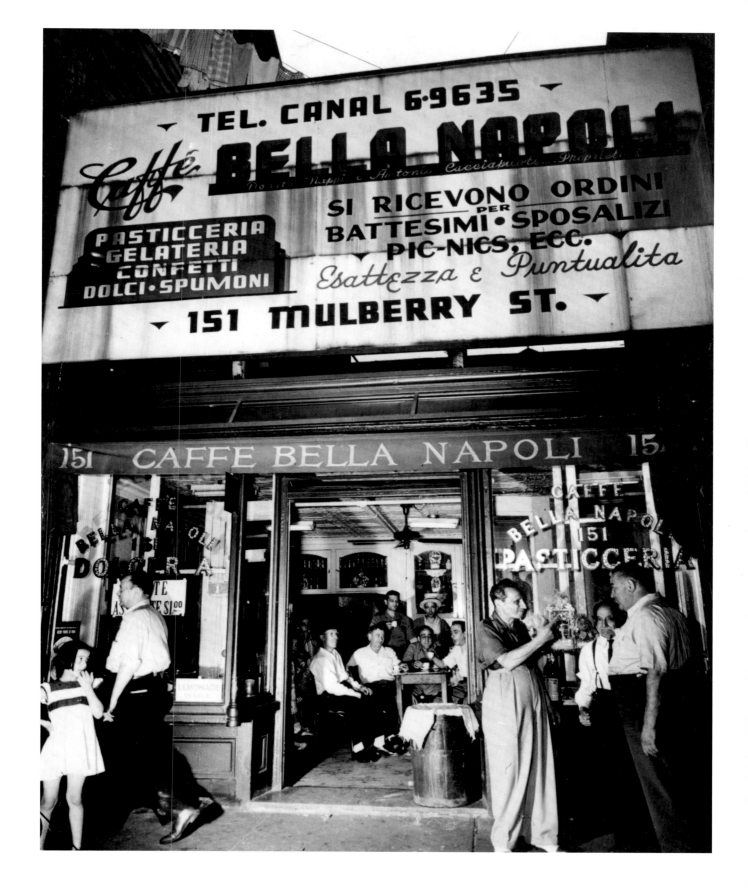

7 September 1944 And the Living Suffer.

Mrs Vanta Supik, the wife of a truck driver killed by Mrs Dorothy Reportella, has to be supported by two policemen as she becomes hysterical over the death of her husband Rudolph Supik. The melodramatic power of this image emanates from its spontaneity and lack of affectation. In an essay entitled 'Shock-Photos', the cultural theorist Roland Barthes said of such photographs that it was precisely the 'naturalness of these images [that] compels the spectator to a violent interrogation, commits him to a judgement which he must elaborate himself without being encumbered by the demiurgic presence of the photographer ... The literal photograph introduces us to the scandal of horror, not to horror itself.'

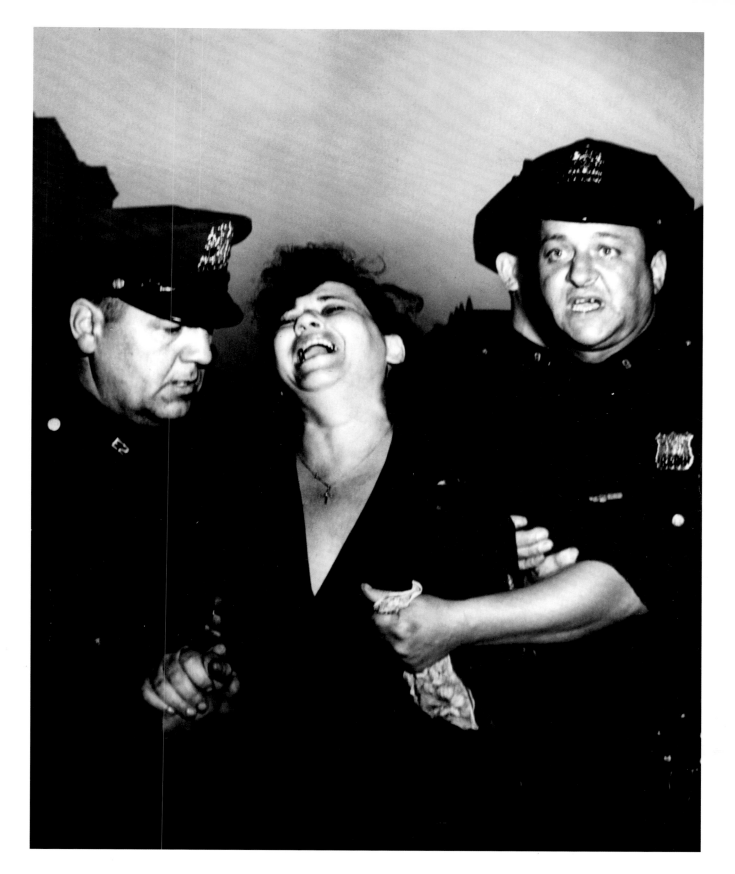

Sudden Death for One ... Sudden Shock for the Other.

Documenting the unfolding events of an automobile accident, Weegee
once again employs a car window to frame the scene. The subject of the
photograph is Mrs Dorothy Reportella. Dressed as if returning from a
night out on the town, she has just hit a bread truck, killing the husband
of the woman in the photograph on the previous page. It appears that the
horrific consequences of the accident have just been recounted to her by
the cop. Doubting the reality of the situation, as if the incident were just
a bad dream, she reaches out to touch his hand. According to the *PM*
story, Mrs Reportella was eventually taken to Bellevue Hospital, suffering
from shock and hysteria.

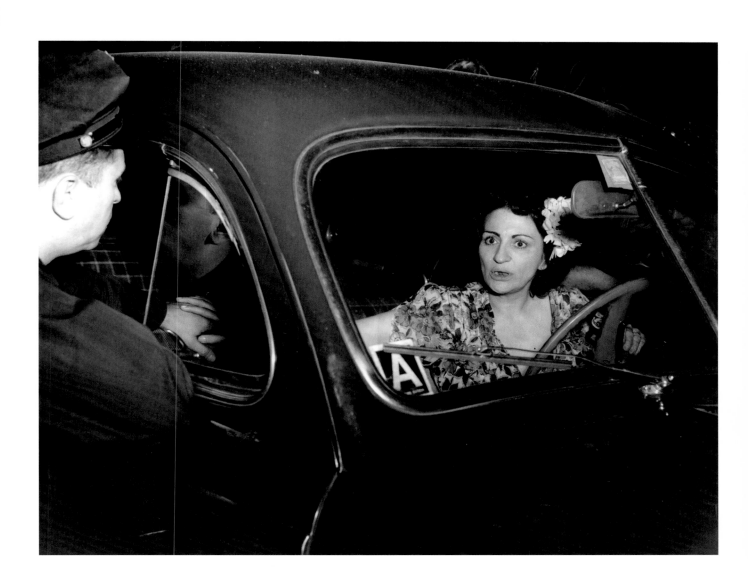

5 November 1944 | And a Girl Smiles ... Then She Cries ... The Swoon.

The sequenced narrative stands out as a relative rarity in Weegee's oeuvre. In the majority of his photographs, Weegee attempted to convey all aspects of a story through a single picture. Mirroring the assorted emotions sparked by Frank Sinatra's songs, this harmonious triptych captures the various moments of the concert through one rapturous girl. Her joy at seeing Sinatra on stage is quickly followed by the tears of a ballad, and concludes with her overcome by the occasion.

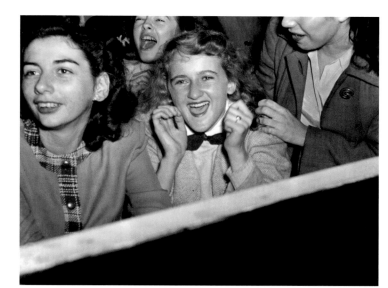

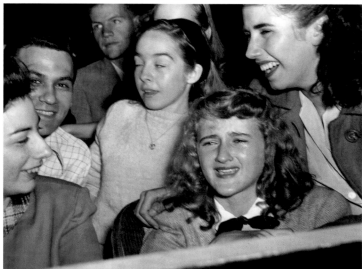

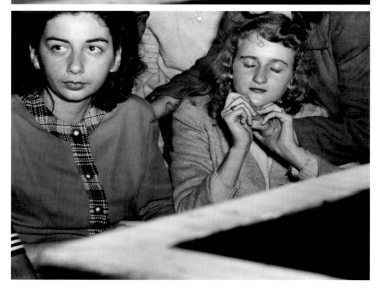

10 November 1944	Arrested for Murder.

In the majority of his 'Pie' wagon photographs, Weegee would appropriate the doorway as a convenient framing device through which to picture the arrested criminal. In this photograph, Weegee chooses to foreground the grill on the wagon door. The crisscross bars serve to heighten the narrowing horizon of this teenage murderer of a four-year-old boy, as he begins to confront the full ramifications of his actions.

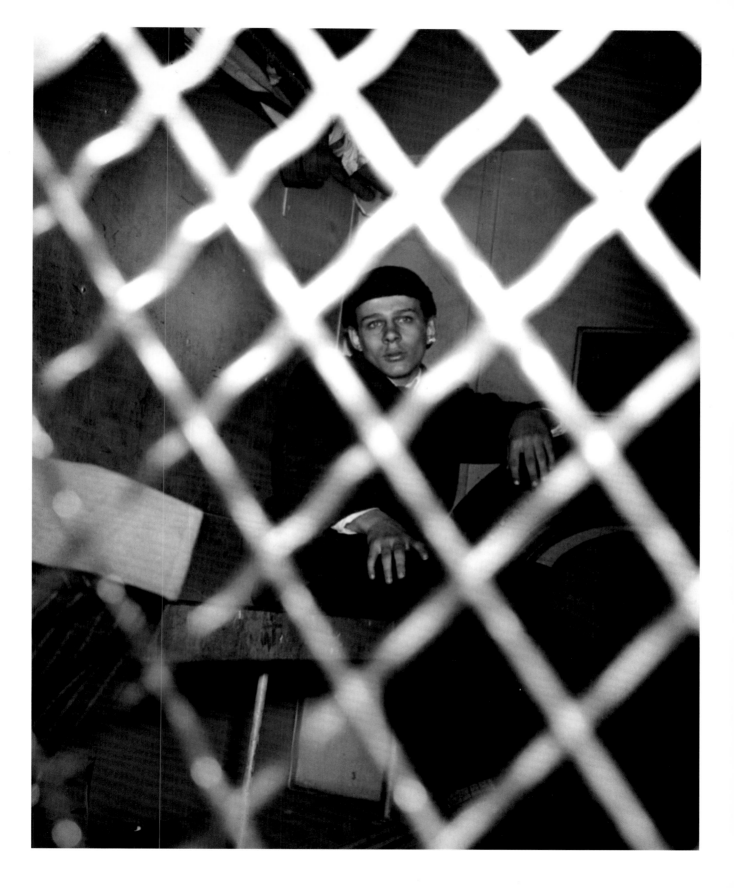

26 November 1944 Metropolitan Opera's Women's Chorus Rehearsal.

On quiet shifts at police headquarters, Weegee would occasionally slip away from the Teletype machine to visit the Metropolitan Opera. With his press card in hand, he would enter the theatre to watch and photograph the rehearsals. Preparing for Richard Wagner's *Lohengrin*, the women's chorus is frozen in mid performance, still dressed in their everyday clothes. The scene bears a striking similarity to Weegee's earlier work of worried spectators observing a fire in a tenement block.

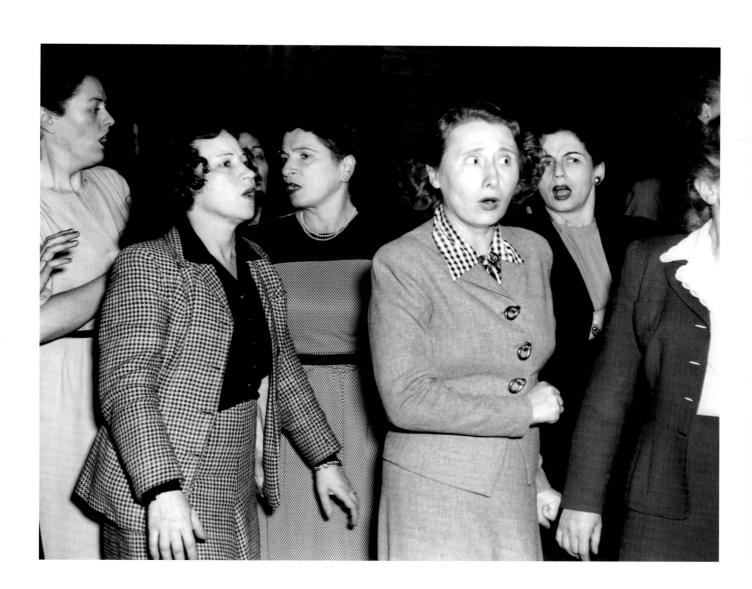

49 3 December 1944 Opening Night at the 'Met'.

Using infrared flash and film, Weegee captures an engrossed audience
watching a performance of *Faust* at the New York Metropolitan Opera. The
spectators are an unlikely group. The seated priest appears impassive and
uncomfortable, while the woman in full-length fur coat is plainly enjoying
the occasion. The standing spectators are younger, poorer and more cramped
for space. The bare arms of the dreamy young woman make the seated lady
seem overdressed. The infrared light from Weegee's flash penetrates the skin
of the man beside her, making his beard seem heavier than it actually is.

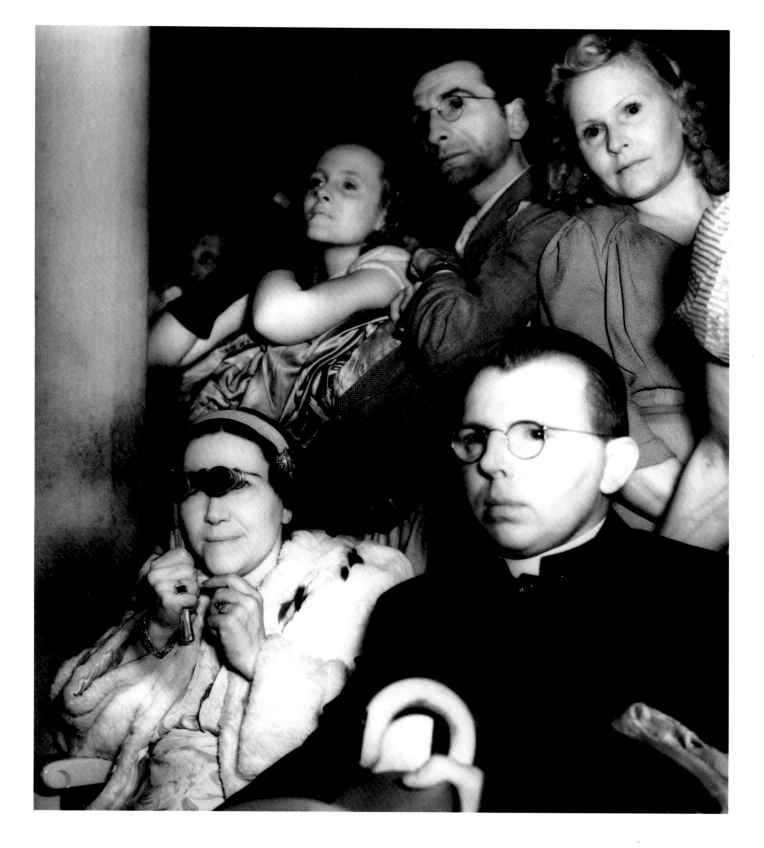

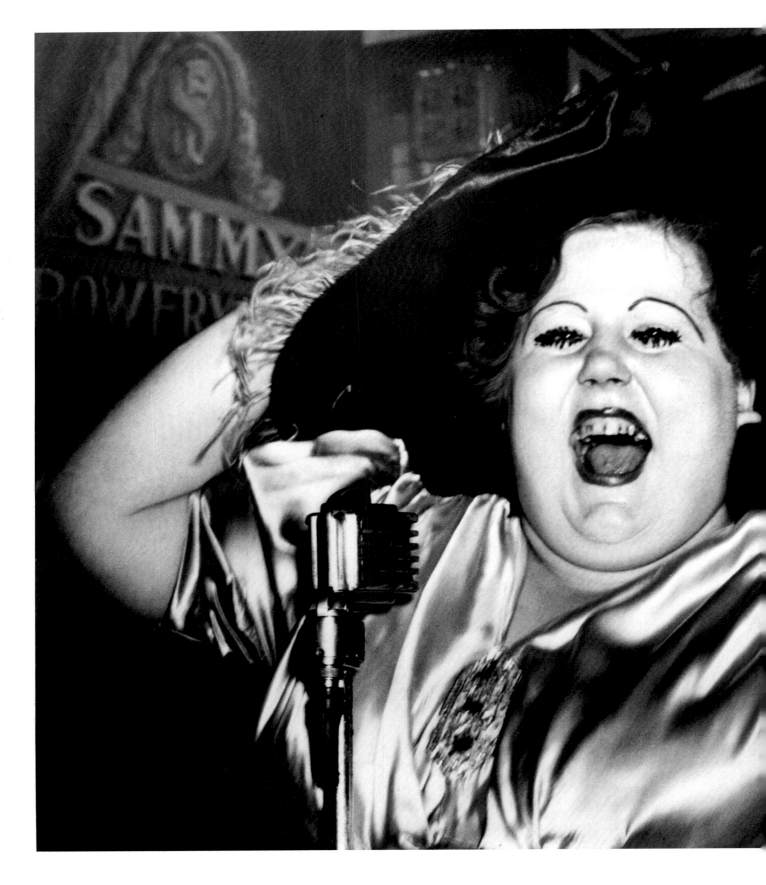

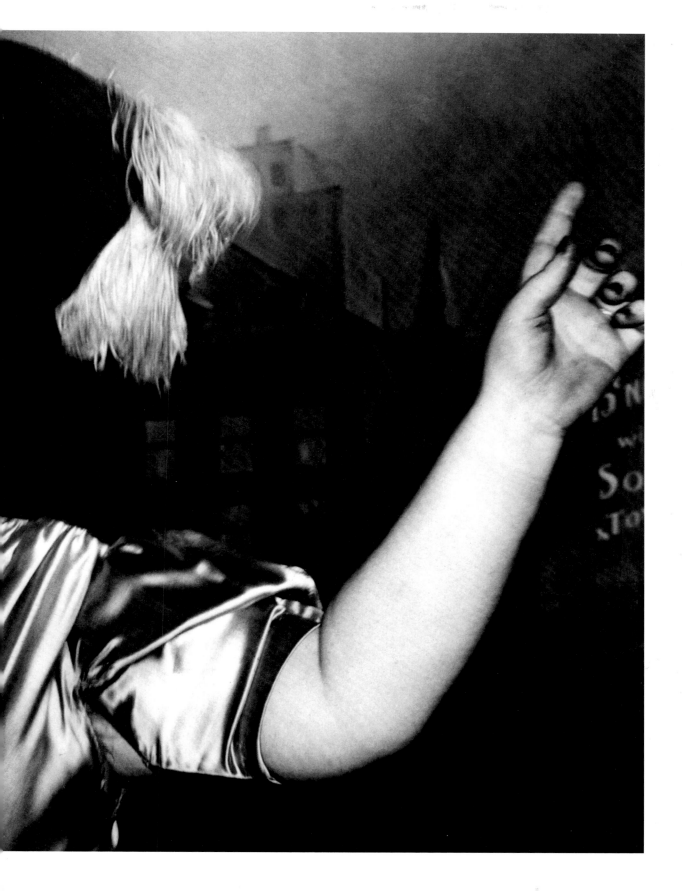

50 *previous page* 4 December 1944 Norma Devine at Sammy's on the Bowery.

Most nights at Sammy's bar, a band or singer would entertain the regulars. For Weegee, the entertainment was a welcome respite from the raw violence on the streets. Norma Devine, known as 'Sammy's Mae West', was one of the best-known acts in the club. In this deliberately blurred image, Weegee captures the full-throated cabaret of her performance, while his flash flattens out the features of her face.

51 28 December 1944 Incident in a Snowstorm.

Seeing this vegetable seller with his horse, Weegee would have been reminded of the pony, nicknamed 'Hypo' (after the fixing agent used in photographic developing), he kept as a young man. Wandering the Lower East Side on the lookout for children who would want their picture taken on the pony was one of Weegee's earliest jobs in photography. The horse depicted here has just regained its footing after falling in the snow.

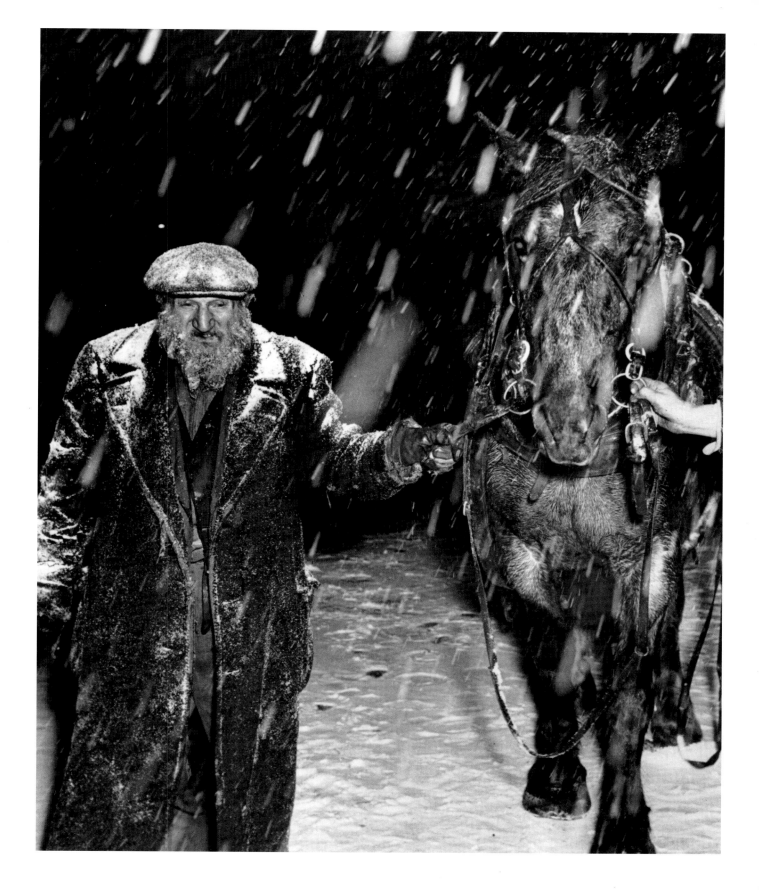

c. 1945 Lovers at the Palace Theatre.

After a decade securing exclusive pictures of murdered gangsters or car accident victims, Weegee became tired of the blood and guts stories. Other assignments, such as this one for *Brief* magazine, came as a welcome respite. The editor asked Weegee to document people eating, sleeping and romancing in the movie theatre. To get this picture, the ever-inventive Weegee hired the services of a model and a young student to pretend to be a couple in the midst of an amorous entanglement. The woman's bare feet curled around the top of the seat and the 3-D glasses of the audience lend a comic aspect to the photograph.

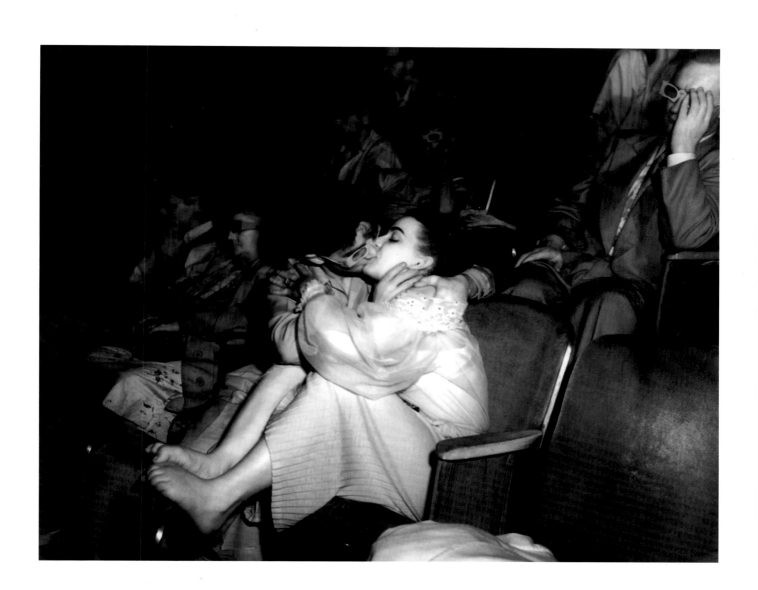

53 25 January 1945 Henry Rosen and Harvey Stemmer.

Photographed at the Elizabeth Street police station in Manhattan, Henry Rosen and Harvey Stemmer have just been arrested for attempting to bribe two Brooklyn College basketball players one thousand dollars each to throw a game. Both Rosen and Stemmer were subsequently sentenced to one year in prison and fined five hundred dollars. Weegee wrote in his autobiography that when a criminal covered his face, he saw it as a personal challenge to get the photograph. From hiding in the police wagon to using remote-control cameras, Weegee would try all the tricks to reveal the accused's identity. Weegee's failure to unmask the criminals on this occasion creates a composition with echoes of the surrealist paintings of René Magritte.

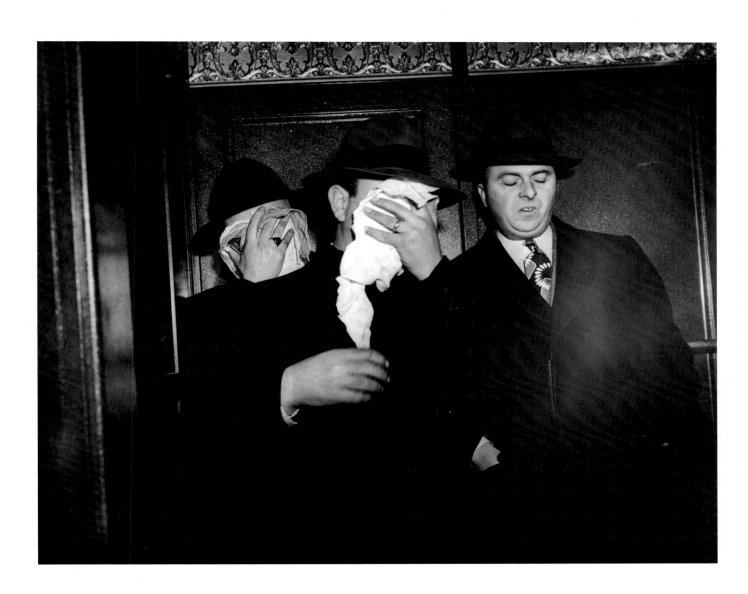

May 1945 | There Was Dancing.

A few days before President Harry S. Truman made the official announcement that war in Europe had ended, people had already started to celebrate in the streets. V-E Day would be on 8 May, but these sailors, accompanied by an impromptu band, anticipate the revelries by dancing the night away in Times Square. Even after 8 May, the war with Japan persisted. While the parties continued throughout the summer of 1945, it was not until V-J Day on 14 August that everyone could truly rejoice at the end of World War II. Weegee documented scenes from these parties for the left-leaning newspaper *PM*.

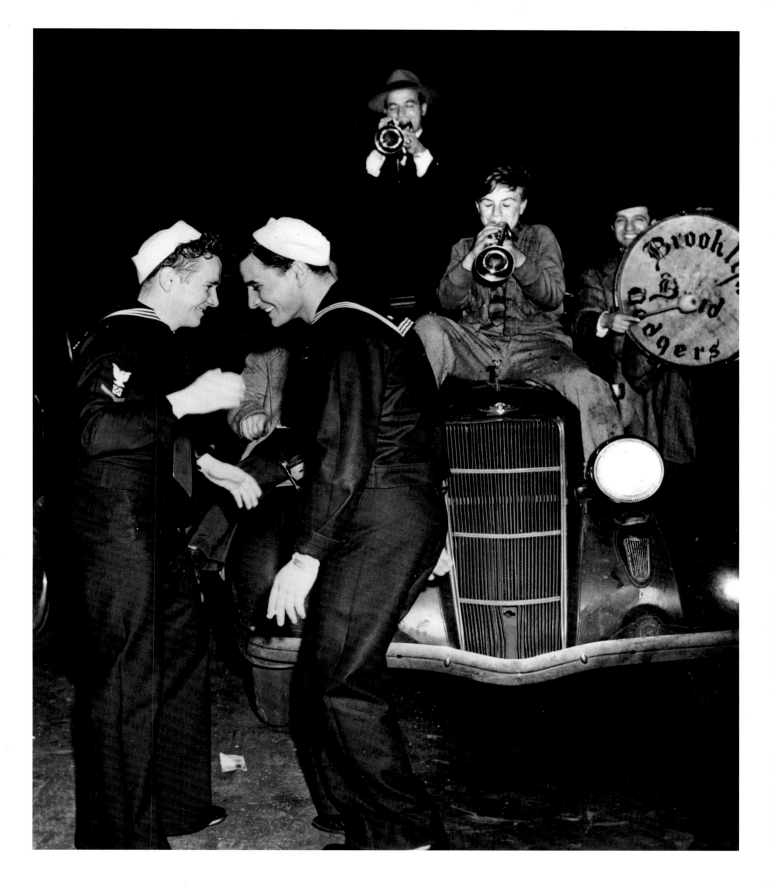

55 c. 1956 Marilyn Monroe.

In the late 1940s, with the knowledge he acquired as a technician at Acme, Weegee began to experiment with different lenses and materials. With these devices, he produced a series of photographic distortions. During his five-year stint in Hollywood, Weegee utilized these new techniques to 'show not only how people looked but what they were like *inside*' (*Weegee on Weegee*). This bloated caricature of Marilyn Monroe pokes fun at Hollywood's obsession with beauty and appearance. It was first published in *Vogue* in 1956.

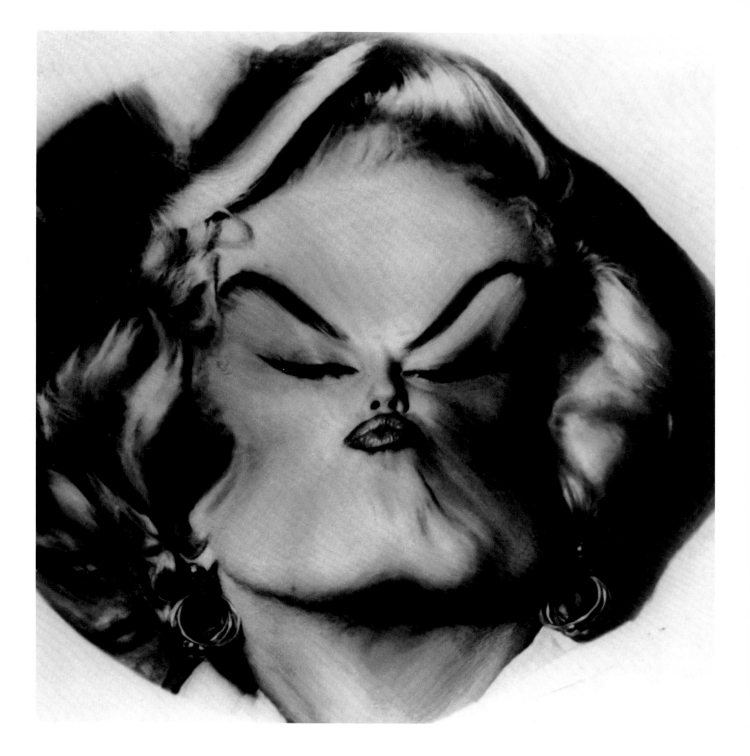

1899	Born Usher Fellig, on 12 June, near Lemberg, Austria (now Ukraine). Parents Rachel and Bernard Fellig.
1910	Leaves Europe for the United States. Upon entering Ellis Island, the immigration officer changes Usher's name to Arthur.
1913	Leaves school to support his impoverished parents. One of his earliest jobs is as a tintype photographer. Buying a pony named 'Hypo', he photographs children at the weekend, selling the prints to their parents.
1917	Leaves parental home. He resorts to sleeping in parks, missions and rail-road stations. He undertakes a variety of menial jobs.
1918	Gets a job as an assistant at the Ducket and Adler photography studios in Lower Manhattan.
1921	Joins the *New York Times* as an assistant in the darkrooms.
1924	Leaves the *New York Times* to join Acme Newspictures as a darkroom technician and printer. He occupies this position until 1935. While at Acme, Fellig begins to work as a photographer. His colleagues begin to call him 'Weegee' (after the Ouija board) due to his uncanny talent for always being the first photographer to arrive at a crime scene.
1935-45	Leaves Acme to pursue a freelance photography career. Over the next decade, his photographs are featured in publications such as the *Daily News*, *New York World-Telegram* and *New York Mirror*. In 1940 he begins to produce photo-stories for *PM*. During this period, Weegee creates some of his most celebrated images.
1938	Obtains permission to install a police radio in his car.
1941	First one-man exhibition opens at the Photo League, New York, entitled 'Weegee: Murder is My Business'.
1943-44	Work features in two exhibitions at the Museum of Modern Art, New York, 'Action Photography' (1943) and 'Art in Progress' (1944).
1945	Duell, Sloan and Pearce publish Weegee's first book, *Naked City*. It becomes an immediate bestseller. The following year Duell, Sloan and Pearce publish Weegee's second book, *Weegee's People* (1946).

1947	Marries Margaret Atwood (no relation to Canadian author). They divorce in 1949. He sells the title of his book *Naked City* to Mark Hellinger, a Hollywood film producer. Offered the role of technical adviser on the film of his book, he moves to Hollywood.
1948	Appears as an extra in the film *Every Girl Should Be Married*. He completes his first short film entitled *New York*. His photographs are included in an exhibition at the Museum of Modern Art, New York, entitled '50 Photographs by 50 Photographers'. During this period, he begins to produce his caricatures and distorted photographs.
1952	After spending five years in Hollywood, Weegee returns to New York.
1953	'Distortions' appear in his third book, *Naked Hollywood*.
1957	Moves in with Wilma Wilcox, who remains his partner for the rest of his life. He is diagnosed as a diabetic.
1958-68	Travelling throughout Europe, works on a variety of projects, including acting as a technical consultant on Stanley Kubrick's film *Dr Strangelove or: How I Learned to Stop Worrying and Love the Bomb* (1964).
1959	Invited by the Soviet government, visits the Soviet Union, giving lectures and exhibiting his work.
1960	Exhibits his photographic 'distortions' in a one-man show at Photokina, Cologne, Germany.
1961	Ziff-Davis publish his autobiography, *Weegee by Weegee*.
1964	Ward, Lock, and Co. publish Weegee's *Creative Photography*.
1968	Dies in New York, at the age of sixty-nine.

Front cover
Crowd at Coney Island, Temperature 89° ...
They Came Early, and Stayed Late.
22 July 1940
(see no. 11)

Phaidon Press Limited
Regent's Wharf
All Saints Street
London N1 9PA

Phaidon Press Inc.
180 Varick Street
New York NY 10014

www.phaidon.com

First published 2004
© 2004 Phaidon Press Limited

ISBN 0 7148 4224 9

A CIP record of this book is available from
the British Library.

Designed by Pentagram
Printed in China